Learn to Draw
in 4 weeks

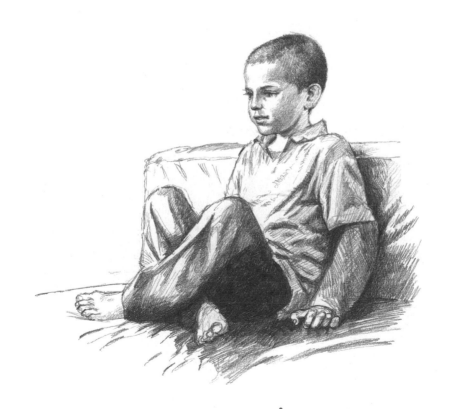

Learn to Draw
in 4 weeks

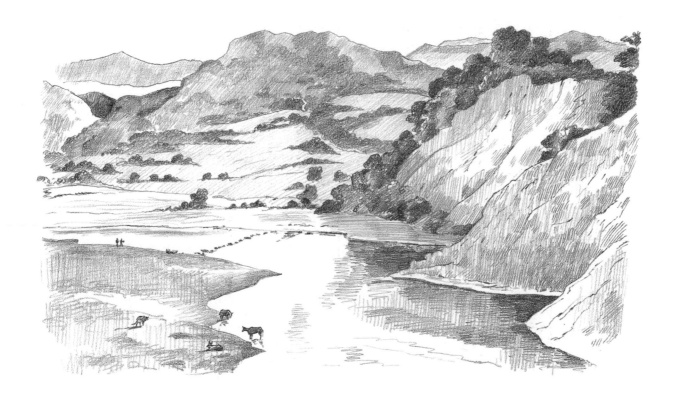

Barrington Barber

SIRIUS

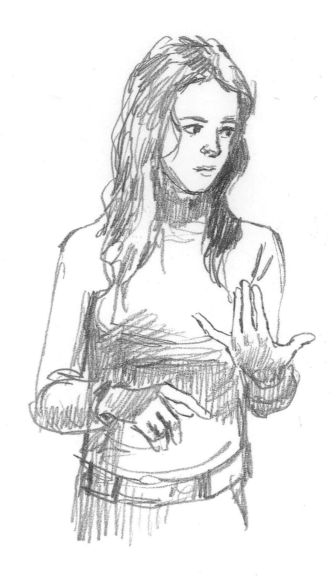

SIRIUS

This edition published in 2024 by Sirius Publishing, a division of
Arcturus Publishing Limited,
26/27 Bickels Yard, 151–153 Bermondsey Street,
London SE1 3HA

ISBN: 978-1-3988-4489-6
AD012148UK

Printed in China

CONTENTS

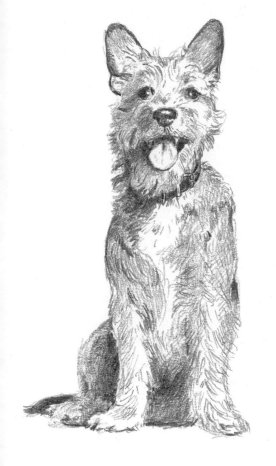

INTRODUCTION

Learning to draw is not difficult – everybody learns to walk, talk, read and write at an early age, and discovering how to draw is easier than any of those processes! Drawing is merely making marks on paper which represent some visual experience. This course starts with just that – making simple marks and doodles with your pencil – before building up your skills progressively over the four weeks. We'll look at all types of subject matter, from simple everyday objects to more challenging themes such as portraits and landscapes.

To keep up the momentum, try to draw every day during the course. Don't be put off by difficulties along the way because they can be overcome with determination and practice and this means you are actively learning, even if it may seem a bit of a struggle at times. Practice is the most useful thing in drawing, and the more you practise the more skilled you will be. So have a go and see how you get on. Good luck, and keep drawing!

Barrington Barber

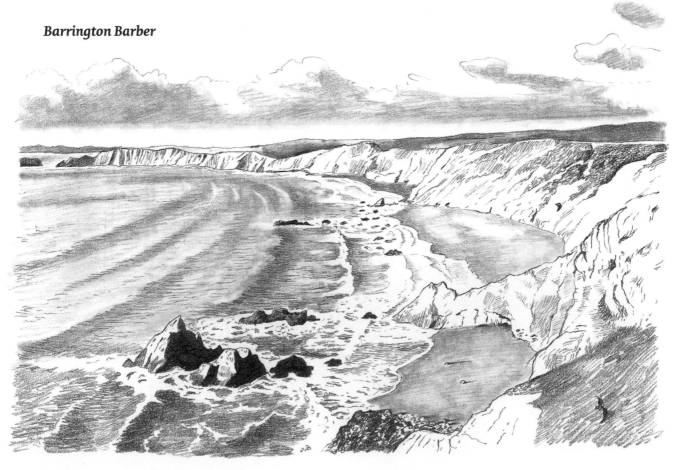

MATERIALS

The first thing to consider before you start drawing is your choice of materials. You can follow this four-week course with just a set of pencils and an eraser if that is your preference. However you may wish to experiment with other materials to broaden your skills and add interest to your drawings.

Pencils, graphite and charcoal

Good pencils are an absolute necessity, and you will need several grades of blackness or softness. You will find a B (soft) pencil to be your basic drawing instrument, and I would suggest a 2B, 4B, and a 6B for all your normal drawing requirements. Then a propelling or clutch pencil will be useful for any fine drawing that you do, because the lead maintains a consistently thin line. A 0.5mm or 0.3mm does very well.

Another useful tool is a graphite stick, which is a thick length of graphite that can be sharpened to a point. The edge of the point can also be used for making thicker, more textured, marks.

Charcoal is basically a length of carbonized willow twig. This will give you a marvellous smoky texture, as well as dark heavy lines and thin grey ones. It is also very easy to smudge, which helps you to produce areas of tone quickly.

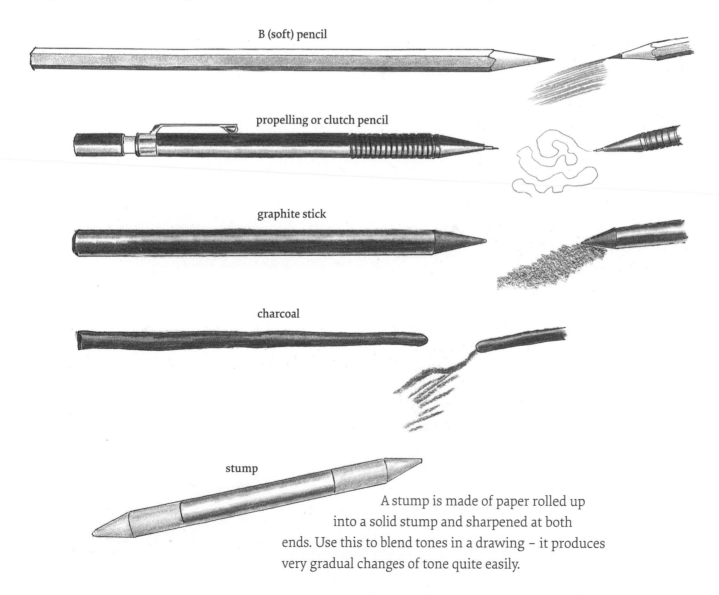

B (soft) pencil

propelling or clutch pencil

graphite stick

charcoal

stump

A stump is made of paper rolled up into a solid stump and sharpened at both ends. Use this to blend tones in a drawing – it produces very gradual changes of tone quite easily.

Pastel/chalk

If you want to introduce colour into your drawing, either of these can be used. Dark colours give better tonal variation. Avoid bright, light colours. Your choice of paper is essential to a good outcome with these materials. Don't use a paper that is too smooth, otherwise the deposit of pastel or chalk will not adhere to the paper properly. A tinted paper can be ideal, because it enables you to use light and dark tones to bring an extra dimension to your drawing.

Conté

Similar to charcoal, conté crayon comes in different colours, different forms (stick or encased in wood like a pencil) and in grades from soft to hard. Like charcoal, it smudges easily but is much stronger in its effect and more difficult to remove.

Indian ink

liquid
concentrated
watercolour

Pen and ink

There are various pens available for ink drawing. The ordinary 'dip and push' pen requires liquid ink and can produce lines both of great delicacy and boldness just by varying the pressure on the nib. With this you will need a bottle of Indian ink, perhaps waterproof, or a bottle of liquid watercolour.

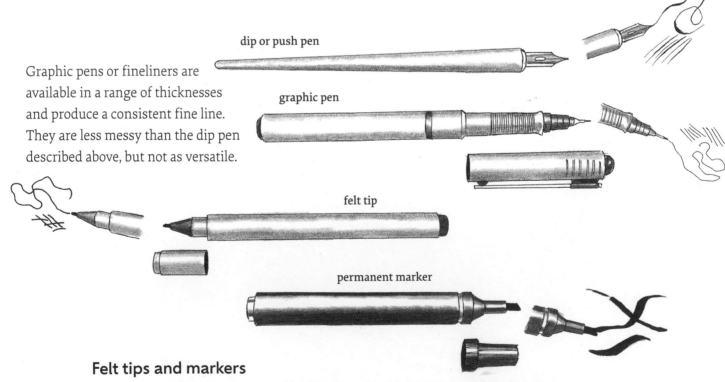

dip or push pen

Graphic pens or fineliners are available in a range of thicknesses and produce a consistent fine line. They are less messy than the dip pen described above, but not as versatile.

graphic pen

felt tip

permanent marker

Felt tips and markers

There are also felt tips, which are thicker than the graphic pens, and permanent markers that produce very thick lines in indelible colours.

Brushes

If you wish to work in brush and wash, you will need a couple of brushes of different thicknesses; I find that Nos 2 and 8 are the most useful. The best brushes are sable hair, but some nylon brushes are quite adequate. Use your brushes with a liquid watercolour as shown on the facing page.

No.2 sable or nylon brush

No.8 sable or nylon brush

craft knife

soft rubber eraser

putty or kneadable eraser

Sharpeners

Don't forget you will need some way of sharpening your pencils frequently, so investing in a good pencil-sharpener, either manual or electric, is well worth it. Many artists prefer keeping their pencils sharp with a craft knife or a scalpel. Of the two, a craft knife is safer, although a scalpel is sharper.

scalpel

Erasers

When using pencil you will almost certainly want to get rid of some of the lines you have drawn. There are many types of eraser, but a good solid one (of rubber or plastic) and a kneadable eraser (known as a 'putty rubber') are both worth having. The putty rubber is a very efficient tool, useful for very black drawings; used with a dabbing motion, it lifts and removes marks leaving no residue on the paper.

MARK MAKING

The first exercise is to reproduce all of the marks shown here, following the instructions. Even if you are already reasonably competent at drawing this will help to improve your manual dexterity. The more often you follow exercises such as these the more your hand and eye learn to work together, making your drawing more skilful.

Don't ignore the aesthetic quality of making marks; try to make your group of exercises look good on the paper. Follow the exercises from top to bottom, left to right.

Start by making a scribbly line in all directions. Limit it to an area and try to produce a satisfying texture.

Next try short, staccato marks that fill the space. Notice how none of them overlap and the spaces in between remain similar.

When you are drawing these more controlled uniform lines, make them all the same length and the same distance apart, keeping them as straight as possible. Repeat these three exercises.

Now take a line for a walk, but don't cross over it anywhere. This may seem rather obsessive, but it is a step on the way to teaching your hand to draw recognizable forms.

Next try a variety of straight lines, again trying to get them straight and the same distance apart, fitting into an imagined rectangle. First do diagonals from lower left to upper right, then horizontals, then diagonals from upper left to lower right. Next, try the two diagonals across each other to form a net, then the horizontals and verticals in the same fashion.

To practise more circular forms, make spirals. Work from outside to inside, clockwise and anti-clockwise, then tighter with the lines closer together; next work from the centre outwards, anti-clockwise then clockwise.

Now zig-zag your pencil up and down.

Use the same action, but incorporate some loops.

Try to produce a dark mass with lines going up and down.

Next, lay another mass of lines horizontally over this dark mass.

Finally, add third and fourth layers, both at diagonals.

The next exploration in mark making is to draw a mass of zigzags in a continuous line crisscrossing over itself.

Now make softer, curvy lines overlapping themselves.

And now cloud-like shapes, going round and round in a continual line overlapping itself.

Next come circles, but not large – lots of them lined up both horizontally and vertically.

Inside each circle, put a nicely drawn spot.

Next make a network of vertical and horizontal lines, drawn very carefully.

Spread a mass of dots over an area as evenly as possible. Remember that this is training for the eye as well as the hand, so the evenness of the dots is important.

Draw several rows of small squares in lines as evenly as possible, as square as possible and lined up both vertically and horizontally.

This exercise is a bit harder to draw evenly, but try it anyway. Make rows of triangles fitting together so that the space between them is as even as possible and they are lined up horizontally and vertically.

Draw rows of spirals joined together as if they were the waves on the sea. Under them draw rows of waves, again as even as you can get them.

For the rest of the exercises on this page, the emphasis is on lightness of touch and control of the direction.

The first one is a vague circular shape of closely drawn lines, light in pressure to create a shaded area of tone.

Now make a series of similar shaded areas, starting from a curved drawn line so that one edge is defined.

Using the same technique, draw horizontal lines.

Shade away from a zigzag edge.

Next, make them vertically.

Then shade away from an S-curved edge.

Then draw them diagonally, slanting to the left.

Now draw a circle and shade inside and outside of opposite edges.

Again working diagonally, start dark with some pressure, gradually lightening the touch until it fades away.

Finally, do the same again only with two circles, one within the other.

BASIC SHAPES

So far, the exercises you have done with your pencil have been a bit like doodling. The next phase is a rather more intellectual one, where you have to envisage a form in your mind before trying to draw it.

First, without too much thought, draw a circle as perfectly as you can. Now close your eyes and see in your mind's eye a perfect circle. It is extraordinary how we can do this yet draw something much less than perfect.

For your second attempt, draw one very lightly with a compass and then go over it in freehand, teaching yourself the way the shape should look. With practice of this kind it won't be long before your freehand circles have improved.

Now try an equilateral triangle – that is, a triangle that has all three sides equal in length. Not quite so easy as it looks, is it? But there is also a mechanical device to help you here: describe a circle with a compass, then draw the triangle within it, all angles touching the circle.

Next, a square. You will know that all the sides of a square are equal in length, and the corners are all right angles, but it can take a bit of time to get that right in the drawing. The mechanical device here is to measure the sides.

Because you are not used to seeing it so much, it is not so easy to draw a square balanced up on one corner, like a diamond shape. You will find it harder to get the sides equal.

Now we move on to slightly more complex shapes. The point of this is to get your eye, brain and hand acting together, so that gradually the practice of drawing becomes easier.

First, draw a five-pointed star without lifting your pencil from the paper. This is also easier drawn inside a circle with all the angles touching it, but try it with and without.

Secondly, try a six-pointed star, which is merely two equilateral triangles superimposed on one another.

Thirdly, draw a star of eight points, which is one square superimposed on another square.

 Now try an egg-shape. This is narrower at one end than the other; draw it with the broader end at the base.

 The crescent is another shape much harder than it looks at first glance, but the secret is to realize that the curve is a part of a circle. Try it freehand and then with a compass-drawn circle to help.

Now we start to look at ways of making things appear three-dimensional, in a conventional way – that is, they are only approximations of perspective, which is the way we tend to see shapes in space.

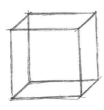 Draw a square, then another the same size but slightly above and to one side of the first. Join the corners with straight lines to link them up, giving a result like a transparent cube.

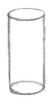 Next, draw a cylinder. First draw an ellipse – a flattened circle – then project two parallel lines vertically downwards to meet a similar ellipse.

 The next figure is similar, but put in only three of the joining lines so that the cube looks solid rather than transparent.

 Try again, only this time leave out the upper edge of the lower ellipse to make the cylinder look more solid.

 Now another way of drawing a cube; draw a flattened parallelogram, like a diamond on its side, and then project straight vertical lines down from the corners of this shape to another diamond shape below. rather than transparent.

 Reverse the process so that the upper ellipse has only one edge; the cylinder now appears to be seen from below.

 This time draw only three of the joining lines and two edges of the lower diamond, so that the cube looks solid again.

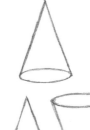 Now move on to cones, which are just two converging straight lines with an ellipse at the wider end.

SHADING

To add shading to your drawings, you will need to practise creating varied tones from light to dark. These exercises require patient, careful manipulation of the pencil. Regular and diligent practice will pay dividends. Begin by drawing a row of eleven squares.

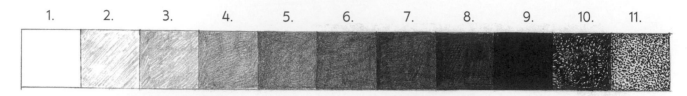

1. Leave the first square blank.
2. Fill the square with a very light covering of tonal lines.
3. Apply a slightly heavier tone all over.
4–7. In the next four squares the tone should become progressively heavier and darker until you achieve …
8. … total black; as black as it gets with pencil.
9. Fill in this square with black ink. Now compare the result with No. 8.
10. Fill the area with many small, overlapping marks.
11. In the final square make many small separate marks that do not quite touch.

This series of technical exercises is designed to enable you to control changes of tone over an area.

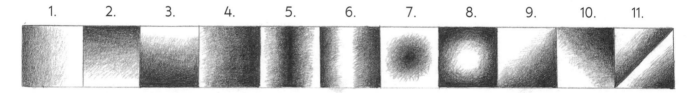

1. Shade from the left side fading to white on the right.
2. Start at the top and fade towards the bottom.
3. Start at the bottom and fade out at the top.
4. Start at the right side and fade towards the left; the reverse of the shading in the first square.
5. Shade across the centre vertically, fading out at either side.
6. Shade from both sides, fading to white in the centre.
7. Shade in the central area, fading out to the edges.
8. Shade around the edges, fading at the centre.
9. Shade from the bottom right corner, fading diagonally towards the top left.
10. Shade from top right, fading to bottom left.
11. Draw a diagonal across the square. In one half shade from the centre fading to one corner; in the other half shade from the corner fading to the centre.

The next stage is to practise making areas of tone on spheres, cubes, cylinders and cones. Shading these shapes will give them a more realistic, three-dimensional appearance.

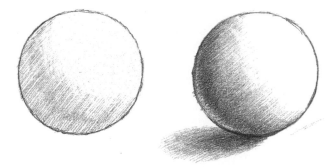

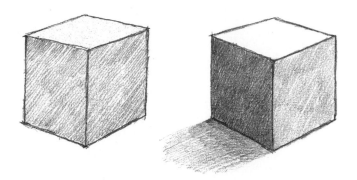

First draw a circle as accurately as you can. Now, with very light strokes, put an area of tone over the left-hand half of the circle. Increase the intensity in a crescent shape around the lower left-hand side of the circle, leaving a slight area closest to the edge to act as the reflected light that you usually get around the darker side of the sphere. Put in the cast shadow on the area that would be the ground, spilling out to the left and fading as it gets further from the sphere.

Now have a go at a cube, covering the left-hand side with a darkish tone. When this is dark enough, cover the other vertical side evenly all over with a much lighter tone. All that is needed then is a cast shadow as before, but fitting the squarer shape of the figure.

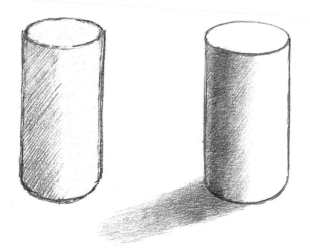

A cylinder is similar to a sphere, but the shading is only on the vertical surface. Again make a column of darker tone just away from the left-hand edge.

With a cone you have to allow for the narrowing shape, which is reflected in the cast shadow.

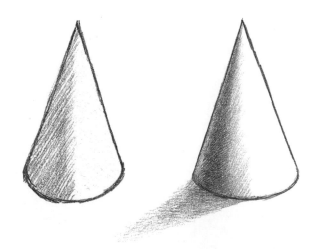

SIMPLE DRAWINGS

While the exercises on the previous spread were quite technical, here we'll look at some line drawings that have their origin in nature. These are all doodles but they are representative of what you might see growing in the countryside or in your garden.

For the first shape, make a small circle with five small lines coming out from it, then draw petal shapes around the outside of the lines. The result looks like a flower.

The next one is similar in design, but the petals are more pointed and there are six of them this time.

Draw a small circle, then put elongated petals around it, one at the top, one opposite at the bottom and one either side to form a cross. Fill in with four diagonal petals. In the spaces between, draw partially visible petals, followed by an outer set.

To draw a Tudor rose, start again with a circle, then put in five sets of small lines radiating from it. Around this, draw a five-petalled rose shape with overlapping edges, then put a small leaf shape projecting from the centre of each petal. Then draw in the last set of petal shapes in between each leaf.

The last flower shape is a bit like a chrysanthemum, with multiple long, thin, pointed petals radiating from a central point.

Next we go on to plant-like shapes with a central stalk. These drawings will help you to get a feel for the way in which natural growth proceeds. The first is just a straight stalk with a leaf shape on the end and additional stalks growing out of the central one, each bearing a leaf. Make the middle leaves larger and the bottom leaves smaller.

In the next drawing there is again a straight stalk, but the branches are all curling. Keep the twigs at the top and bottom simple and allow the middle layers to be more complex. Notice how some curl one way and some the other. Play around and experiment.

Here the stalk is drawn more substantially, thickest at the base and tapering to a point at the top. Draw the lower branches also with a bit of thickness and allow small, straight twigs to branch off in all directions. Try to maintain the same growth pattern all over the plant.

The last drawing is a similar growth pattern, but this time all the branches and twigs are curly. Start with the central trunk and add the thicker branches first before putting in the smaller ones. Have fun and be inventive.

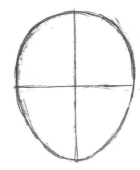

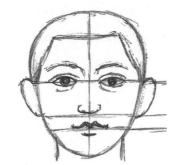

Now we move on to the human head, hand and foot. Like the plant forms, these are diagrammatic drawings, but they give you a good idea of the shape and proportion of the human head and extremities.

Start by drawing an oval like an egg perched on its smaller end, then divide it halfway both vertically and horizontally.

When the head is upright and facing you directly the eyes are halfway down. On the average face, the end of the nose is halfway between the eyes and the bottom of the chin. The mouth is about one-third nearer the nose than the bottom of the chin. There is about one eye length between the eyes, and also between the eye and the outer side of the head.

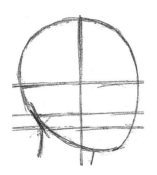

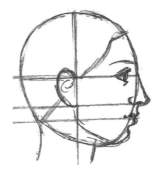

From the side, the head is as wide as long. Divide as before, placing the ear behind the halfway vertical.

Project the nose, mouth and chin beyond the oval. The length of the ear is from about the eyebrow down to the bottom of the nose. Notice the shape of the eye seen from the side.

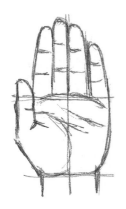

The hand is a simple block shape, with the palm almost square and the fingers about the same length as the palm. Draw a central line and this will be where the fingers divide two and two. They tend to taper a little towards the top, and the middle finger is usually the longest, with the forefinger or third finger coming next, then the little finger.

The foot is simpler, especially when seen from the side. Notice how the toes curve and how they tend to be progressively shorter from the big toe to the little one. Some people have the second toe longer than the big toe, but this is variable.

The thumb is usually a little shorter than the little finger, but appears much more so because it starts lower down the hand. Check with your own hand, noticing the knuckles on the back and the padded fleshy parts on the palm.

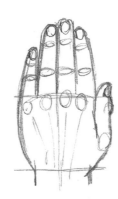

OBJECTS AND SHADING

The exercises over the following pages should be fun, so try to feel at ease as you do them. Don't grip the pencil too tightly, keep your shoulders relaxed and don't hunch up or get too close to your work. Don't worry about mistakes – just correct them when you see them. To begin, you will need to have some simple household objects in front of you. I have chosen some items from my own house – yours don't have to be exactly the same, but it will help you to follow my drawings as well as having the actual object in front of you.

Before you start, look very carefully at each object to familiarize yourself with its shape. I have used glass objects for the first exercises, because you can see through them to understand how the shape works.

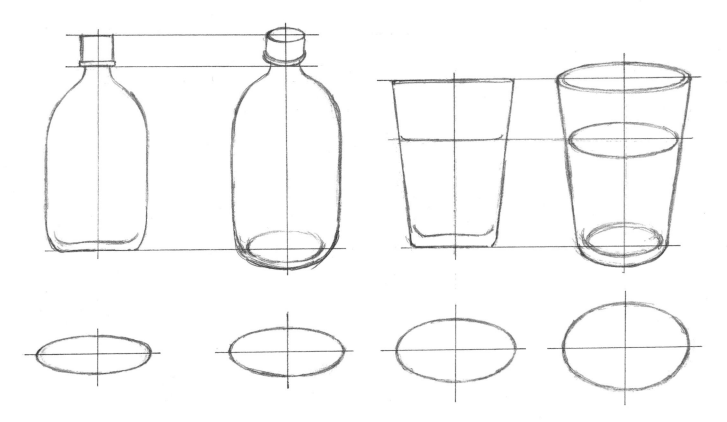

My first object is a bottle, seen directly from the side. As it was exactly symmetrical, I put in a central line first. Then I drew an outline of its shape including the screw top, making sure that both sides were symmetrical.

From a higher eye-level, I could see the bottle's rounded shape. To show this I needed to draw the elliptical shapes that circles make when seen from an oblique angle. Again I carefully constructed the shape either side of a central vertical line.

The ellipses shown below the bottles demonstrate how they become flattened to a greater or lesser degree depending upon the eye-level from which a rounded

object is seen. Although they become deeper across the vertical axis the further they are below your eye-level, the horizontal axis remains the same width. Don't be put off by the difficulty of drawing them, because even professional artists don't find them so easy; with practice, you will be able to draw them well.

The next object is a glass tumbler with some water in it – slightly easier to draw than the bottle because it has straight sides. Draw the outline first at eye-level and then seen from slightly above. In the latter drawing there are three ellipses: the top edge of the glass, the surface of the water and the bottom of the glass.

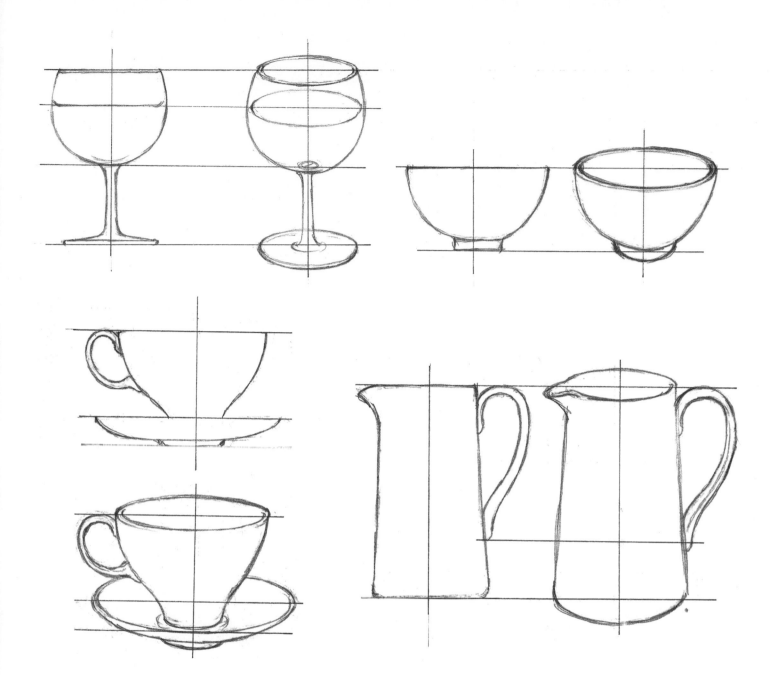

The third object, a wine glass with some liquid in it, is a bit harder. Here you will see that there are three ellipses of varying width, but the object is still symmetrical from side to side. Go carefully and enjoy discovering the exact shape.

Next, some opaque subjects, starting with a bowl. The side view drawing is easy enough; make the curve as accurate as you can, and then tackle the view from just above. This time you aren't able to see through the sides, so you have only one edge of the lower ellipse to draw.

The cup and saucer is more complex, but with a bit of steady care and attention you will soon get the shape right. Drawing it from above is a little harder and because you can't see through the porcelain it might be trickier to get the lower ellipses right first time.

The jug should be a bit easier after the cup and saucer, and it is placed here on purpose so that the effort you make on the more complex drawing pays off on the easier one. As before, draw the exact side view first before you depict it more naturally, seen from slightly above.

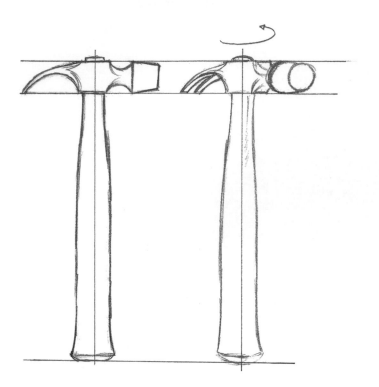

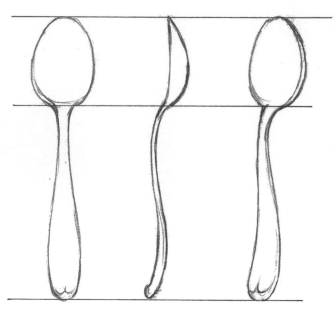

Now you're ready to move on to a series of objects which are of varying difficulty. The drawing of the hammer is quite easy from the exact side view but is a bit trickier from a more oblique view.

There are two ways to draw the spoon, from the exact front and from the exact side, before you try a more natural view.

The pot is not too difficult if you have completed all the other objects so far, and the box is very simple – but beware of the third version, a slightly more complex view where the perspective can easily go wrong.

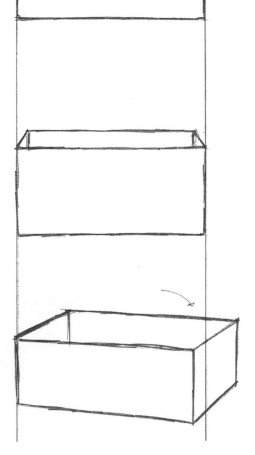

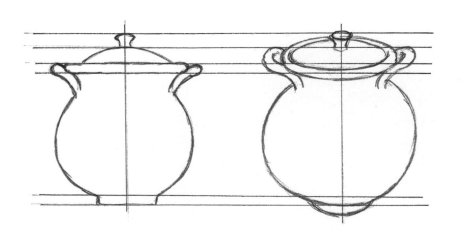

Add Shading

All these objects are simple enough in outline. However, as with the shapes on page 15, to make them look more three-dimensional and substantial, the use of shading of some sort is needed.

First make line drawings of the objects as accurately as possible. On the book, shading to show the curve of the spine and fine lines giving an effect of the packed pages is almost all there is to do, with the addition of a small cast shadow to anchor it to a surface.

The pot needs quite heavy tone in the interior space to give some idea of the inner hollow. Then add a graduated tone around the cylinder and a small cast shadow to complete the picture.

The apple needs to be shaded in a vertical direction between the upper surface and the bottom, concentrating on the left-hand side to indicate the direction of the light. Also add a cast shadow and some shading where the stalk comes out of its hollow.

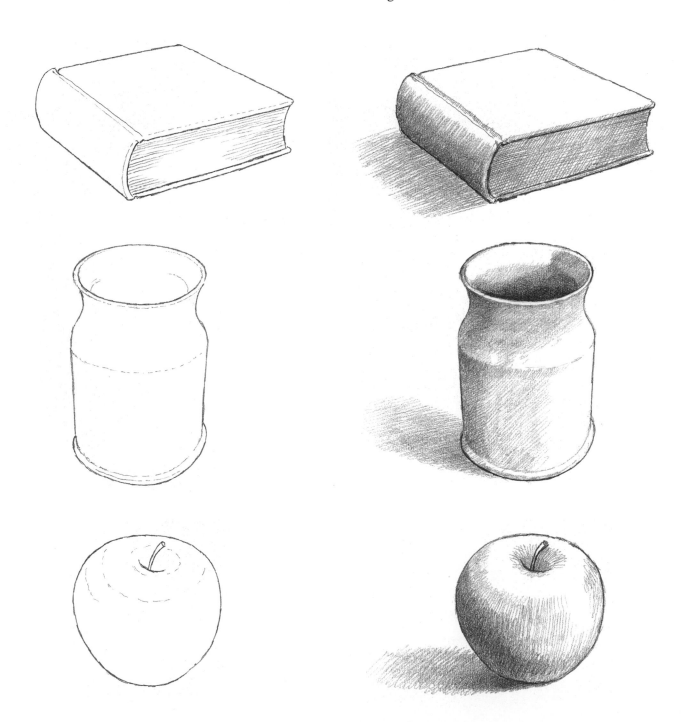

DRAW OBJECTS IN STEPS

Once you gain confidence in shading simple objects, you can start to make some more finished drawings, taking them step by step. First we return to a cup and saucer, because this pair of closely fitting objects is fairly simple but with enough complexity to be a good test of your newly acquired skills.

Step 1

First draw the ellipses to show the top and bottom of the cup, and the main shape of the saucer. Draw the handle shape and the curved sides of the cup.

Step 2

Put in the main areas of shade with a single tone. Keep the tone light at this stage: a soft hatching technique works well when using pencil. Pay attention to the inside of the cup and to the tones on the side of the saucer.

Step 3

Lastly, work up the tones until you get a good likeness of the shape and reflections on the objects.

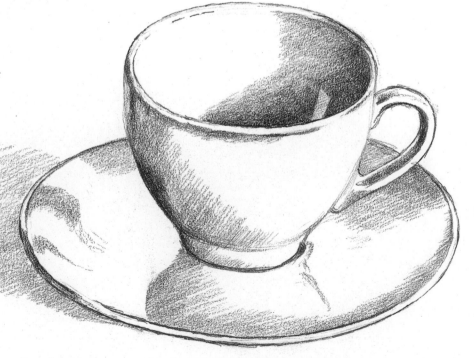

This next object is more difficult. This is a child's chair, viewed from an angle that reveals the spaces between the rungs and the back of the chair.

Step 1

Keep the drawing loose and open to start with, so that you can link the legs and rungs across the main structure.

Step 2

Then, firm up the drawing by outlining each part more precisely. Take your time to get the shapes right at this stage, referring to the drawing of the negative spaces (below left) as needed.

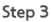

Step 3

Having completed the shape to your own satisfaction, put in some simple toning to give it solidity.

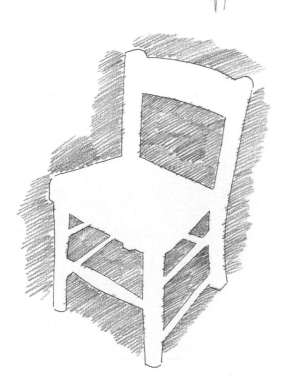

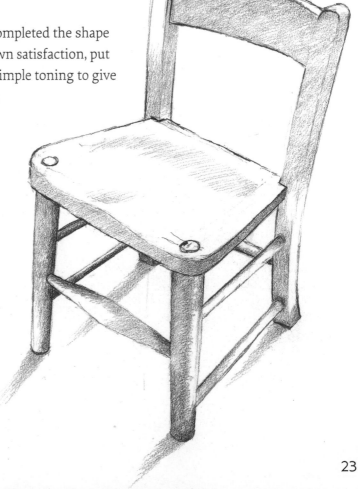

The diagram shows the negative spaces drawn in: careful observation of the spaces between the parts of the chair will enable you to check your drawing; if the spaces are not correct then you know that you have some part of the basic structure wrong as well.

DRAW YOUR OWN HAND

In this first week of drawing there is no need to attempt the whole human body, which is probably the hardest thing that we artists ever have to draw. Instead, let us tackle just one part: the hand. We looked at the proportions of the hand in the diagrammatic drawing on page 17 – now the aim is to create a more realistic representation based on close observation.

If you are unsure of the correct proportions, repeat the diagrammatic drawings shown on page 17, or trace around the outline of your hand spread flat on the paper. When you are ready to draw your hand from direct observation (as shown here) this will show up any discrepancies in proportion.

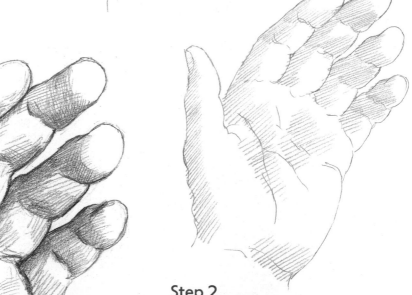

Step 1

Hold your non-drawing hand up in front of you, keeping it as still as possible, and observe it closely before you start to draw. Make a light outline of the palm, fingers and thumb. Now, indicate obvious creases on the palm and fingers.

Step 2

Next, put in the main areas of shade all over, in a light tone. Try narrowing your eyes to help identify the areas of light and shade.

Step 3

Lastly, work up the details of creases in the skin and the darker tones of shade, so that the hand starts to look three-dimensional. Do not overdo the tone.

PLANT GROWTH

Drawing a plant is not quite like drawing an inanimate object, because the plant does tend to move around very slightly and gently rearranges its position in space. The important thing is not to try and draw everything exactly, but to convey a feeling of growth and sensitivity. Try and avoid using heavy lines, especially at the beginning.

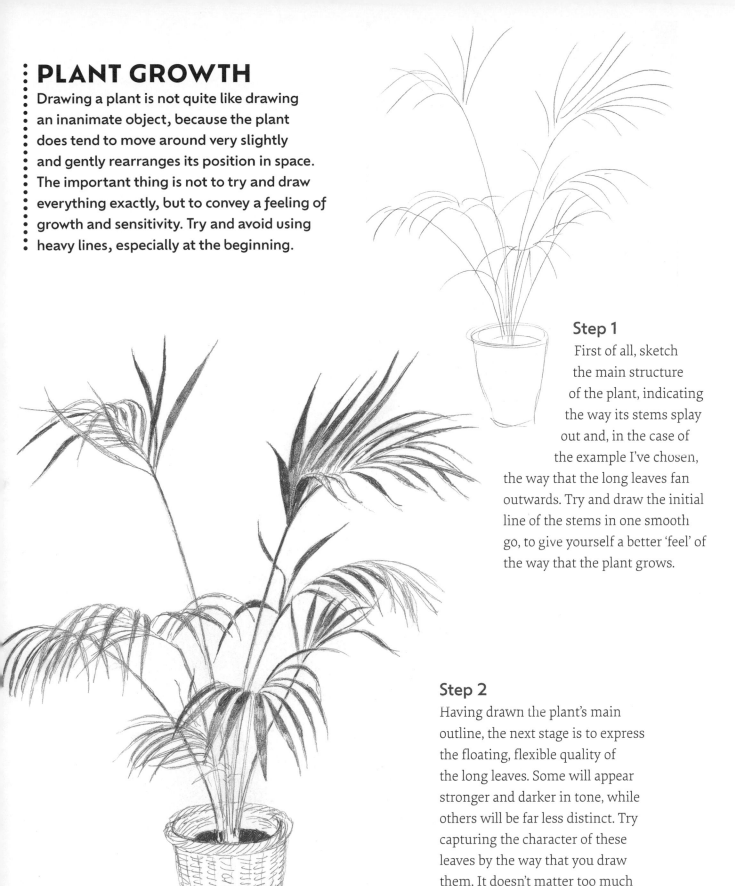

Step 1

First of all, sketch the main structure of the plant, indicating the way its stems splay out and, in the case of the example I've chosen, the way that the long leaves fan outwards. Try and draw the initial line of the stems in one smooth go, to give yourself a better 'feel' of the way that the plant grows.

Step 2

Having drawn the plant's main outline, the next stage is to express the floating, flexible quality of the long leaves. Some will appear stronger and darker in tone, while others will be far less distinct. Try capturing the character of these leaves by the way that you draw them. It doesn't matter too much if, when you look back at the plant, they seem to have altered. Total accuracy is not essential here.

DRAW A TREE

To finish this week's exercises, challenge yourself by drawing a tree. The key to drawing trees is to look at the overall shape first and sketch that in without concerning yourself over any of the detail. Don't try to draw every leaf or even every branch, because you will soon lose track of what you are doing. Stick to the most visible branches and the larger clusters of leaves.

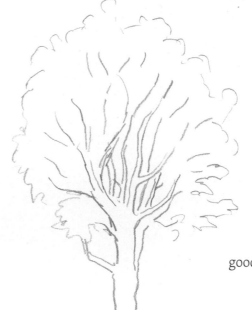

Step 1

First, establish the outer shape of the foliage and the shapes of the main branches. This defines the structure and makes a good basis for your drawing.

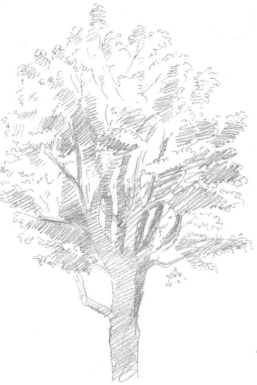

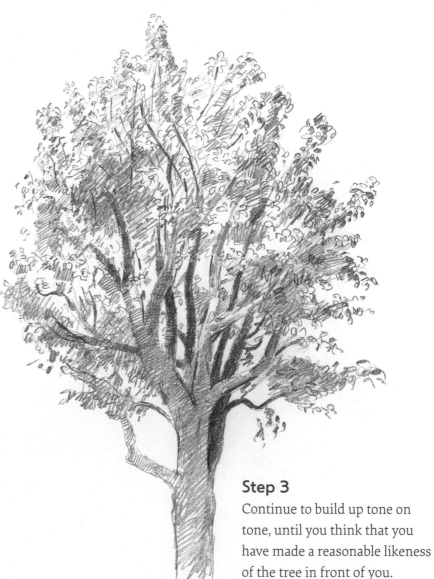

Step 2

Next, put in all the dominant areas of shade, leaving the top clusters of leaves highlighted in the sunshine. Make the farthest branches darker in tone so they appear to recede in space. Now, build up the tones on both the foliage and the branches, using a scribbled texture of leaf shapes for the former, and marks that shade in accordance with the contours of the branches for the latter.

Step 3

Continue to build up tone on tone, until you think that you have made a reasonable likeness of the tree in front of you.

TEXTURES AND MATERIALITY

To start this second week, we look at developing a feel for different types of materials and transferring their textural qualities on to paper. As with the first exercises on pages 10–11, take care over the appearance of your drawings as a group.

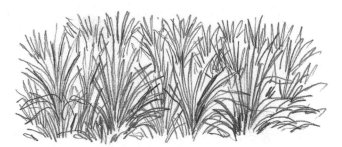

Grass

The first of these drawings of texture shows an impression of an area of grass-like tufts – that is to say, very conventional patterns that resemble grass, not drawings taken directly from life. When you have tried the stylized version, you could go and look at a real lawn and try to draw that from life.

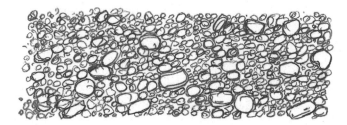

Beach

Next, a drawing that resembles a pebbled beach, with countless stones of various sizes. Again, after drawing a conventional version like this, you could try working with a real area of pebbles or stones.

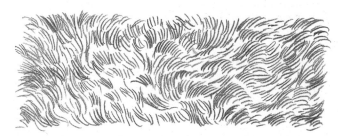

Fur

This resembles fur, such as on a rug or the back of a cat. The short, wavy lines go in several directions, but follow a sort of pattern.

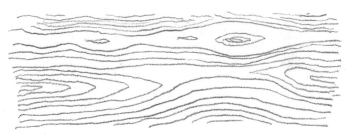

Wood

Now try doing this wooden plank, with its knots and wavy lines of growth. The floorboards in your house might be a good example of this kind of wood pattern.

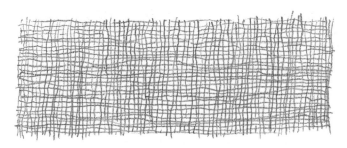

Mesh

This carefully drawn mesh looks a bit like a piece of hessian or other loosely woven cloth. Make sure that the lines don't get too heavy or the cloth-like effect will be destroyed.

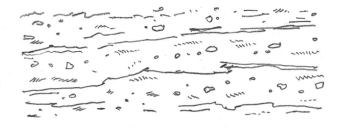

Rock

This drawing shows the surface of what might be a piece of grained and fissured rock. Again, after trying out this example, have a look at the real thing which will show you how comparatively stylized this pattern is.

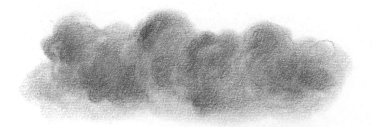

Clouds

This smoky texture is produced by using a soft pencil, then a paper stump to smudge the dark areas. After that, a little rubbing of some of the darker parts gives a cloudy look.

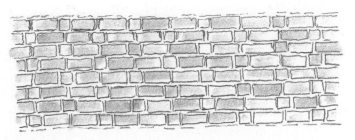

Brick

This brickwork effect is not difficult but is a bit painstaking. The trick is to keep the horizontals as level as possible but draw the edges rather wobbly, which gives the rather worn look of older bricks. Smudge some tone on some of the bricks, varying it rather than making it even.

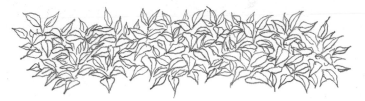

Leaves

All that is needed to give the effect of thick, hedge-like leaves is a large number of small leaves drawn adjacent to and overlapping each other. Try to maintain a certain amount of variety in the angles of the leaves to make them more convincing.

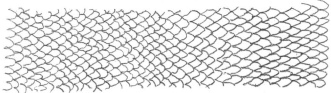

Snakeskin

Drawing snakeskin or fish scales is just a matter of drawing many overlapping scale shapes without being too precise or you will lose the movable look of natural scales. Again, it requires a rather painstaking effort, but apart from that it is easy.

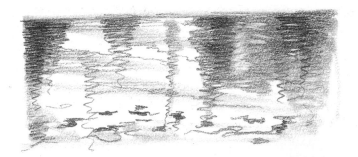

Water

This watery texture is achieved by keeping all the marks you make horizontal and joined together to create the effect of ripples. Smudge a little of the drawing to create greyer tones, but leave some untouched areas to look like reflected light.

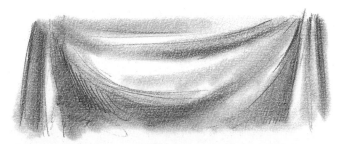

Drapery

This drapery is done by drawing descending curves to emulate cloth, and then using a paper stump to smudge and soften the edges of the tone. The only sharp lines should be at the sides where the cloth appears to be gathered up.

PRACTISING TEXTURE

In the next three exercises we go a step further with textures, exploring a girl's long curly hair, some fabric and a woven basket.

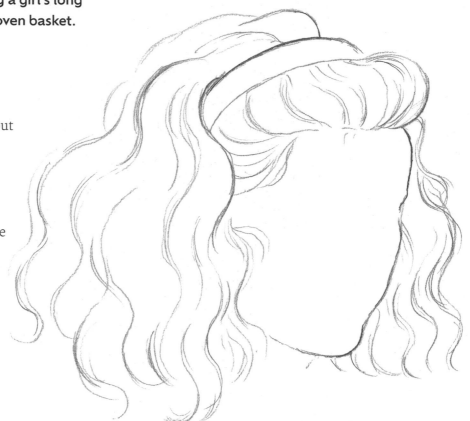

To start with, draw a very careful but simple outline of the shapes of the cascading hair, getting a feeling for the way it winds and curves as it grows away from the head. It doesn't matter if you don't get some of the waves of hair quite right as long as the main shapes are followed.

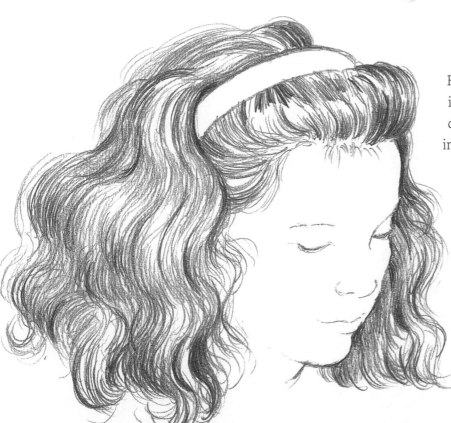

Having got the main shapes of the hair in place, you can now build up a texture of lines and tone to produce a convincing impression of the way it looks. Your pencil strokes should follow the main shapes of the curves of the hair, in some cases drawn heavier and darker and elsewhere drawn much lighter and fainter. This gradually produces the look of hair in waves. Notice how often at the edges of the mass of hair the tone looks darker, and how there is a contrast between the dark under-curve and the lighter upper curve where the larger waves curl round.

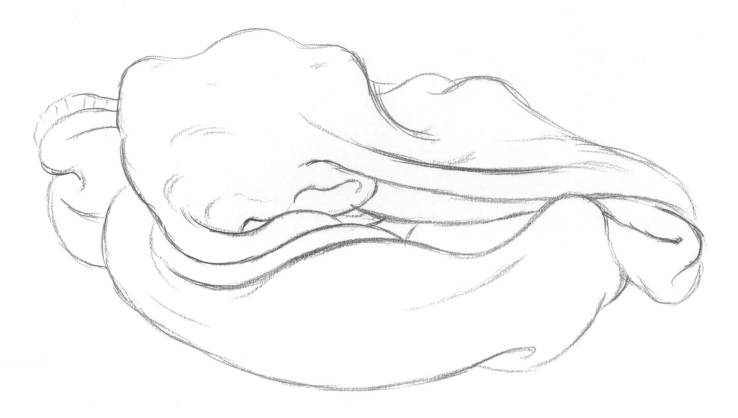

With this fabric, first notice the main folds and carefully draw them in as accurately as you can. The texture here is much simpler to draw than hair, just needing either darker or lighter tones to indicate the folds. As this particular piece of fabric is an old sweater, it can be drawn softly and slightly rough in texture to indicate the look of wool.

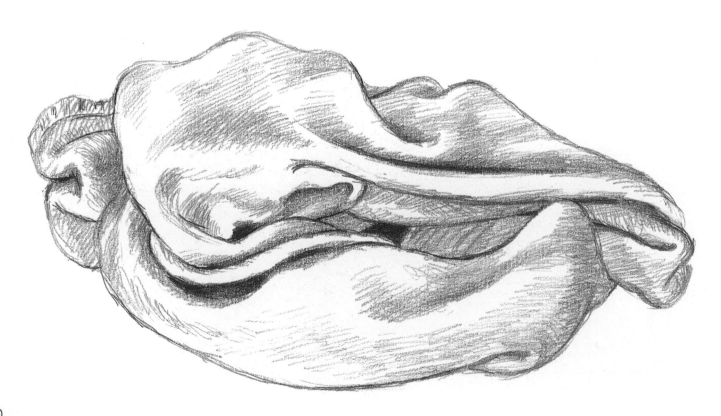

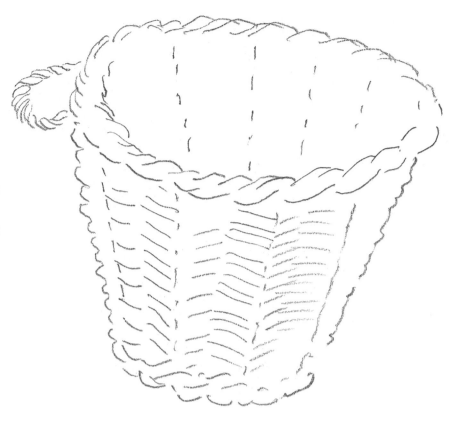

Now for another kind of texture – a wicker basket. As before, draw in the main shapes of the basket first, being careful to get some idea of how the woven strands in the basket weave in and out of each other.

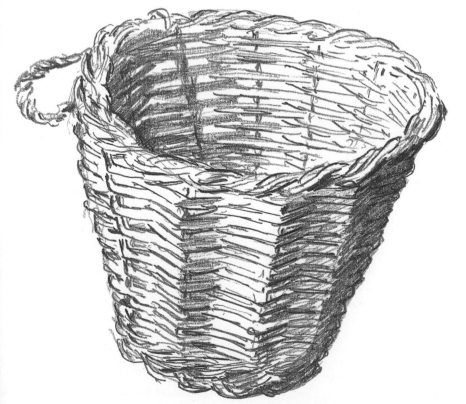

The difficulty is to achieve the effect of the interweaving strands of the basket without drawing every one exactly. Try to obtain a general impression with the lined-up marks so that the weaving looks uniform enough without appearing too clean-cut. The texture of basketwork is not very precise, and you can exploit this fact to give a good impression rather than try to draw every strand exactly. Make sure that the shaded parts are strong enough to convince the eye of the depth of the space inside and around the object. Try not to overdraw on the lighter areas so that the contrast between the two parts will work better for you.

DRAW A DOG

Drawing an animal will be a great test of your progress so far. If you have a pet at home you can draw from life, but you may find it easier to work from a photograph or follow the steps shown here. In this drawing, the focus is on the textural lines used to show the dog's rough coat.

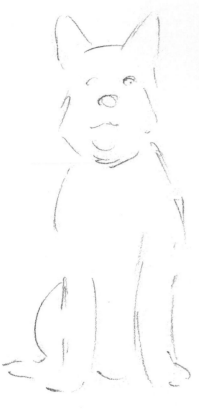

Step 1

Very lightly sketch in the main shape. I worked from a photograph, so that I would have plenty of time to draw the dog's expression and lolling tongue.

Step 2

Next, make a light outline of the main shapes of the dog.

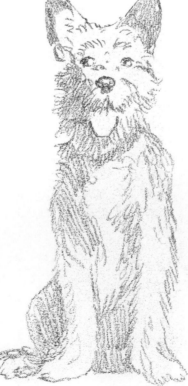

Step 3

Put in the shaded areas next, using a light uniform tone and rough, scribbly marks to convey the texture of the dog's fur. Even with a rough-coated dog, there will be areas of highlight.

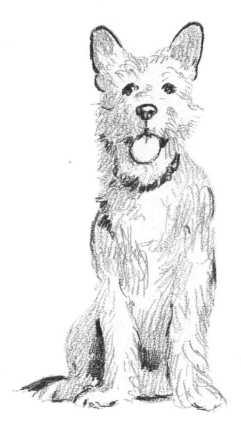

Step 4

Mark in the darkest tones to help define the dog's shape. The colour of the fur is quite pale, so these are not extensive.

Step 5

Now work over the whole picture to build up an impression of fur and gleaming eyes and nose. To describe the fur texture, make pencil marks in the direction that the hair grows. This varies over the whole body of the dog.

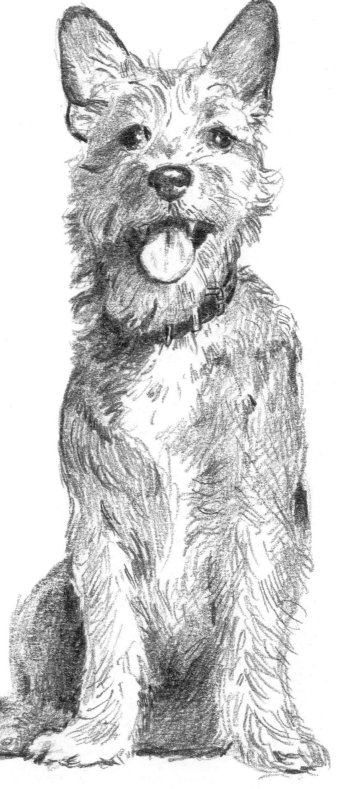

EXPLORE MORE TEXTURES

Anything that is drawn needs to show some evidence of awareness of its actual material constitution. There are well-known ways of drawing that make it quite clear, in the context, of the materiality of the subjects drawn. Here are some examples.

Leather

This leather shoe is dark and well polished, so there are strong contrasts between the light and dark areas. Study it carefully and observe how those light and dark areas define the shape of the shoe, as well as its materiality. Notice how the very darkest tones are often right next to the very lightest, which gives maximum contrast.

Metal

The metal object I have chosen is a highly reflective piece of hardware – a shiny saucepan. Reflections on this type of surface can become very complicated to draw, so it is a reasonable decision to simplify them to a certain extent. Make sure you represent all the main areas of dark and light and, as with the shoe above, note that the very brightest is often placed next to the very darkest. The interior of the pan is not so clearly reflective and you should show the difference between the inside and the outside. The cast shadow is important, because that is also reflected in the side of the pan and helps to reinforce the illusion.

Straw weave

A straw hat produces a clear-cut form with definite shadows that show the shape of the object clearly. The texture of the straw, woven across the structure, is very distinctive. Well-worn hats of this kind tend to disintegrate in a very characteristic way, with broken bits of straw disrupting the smooth line.

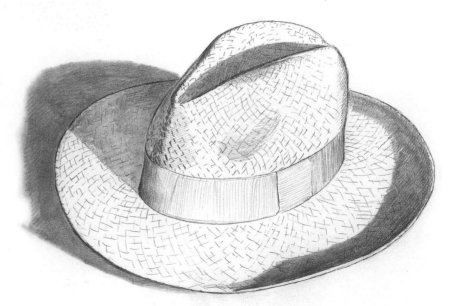

Stone

Natural forces can shape and form the texture of a very hard substance, as these examples show. Each is at a different stage of weathering, with the chunky piece of rock (right) not yet eroded to the stature of the rounded pebble (below). The pebble has been virtually worn smooth by the action of water and other pebbles, save for a small hollow that has escaped this process.

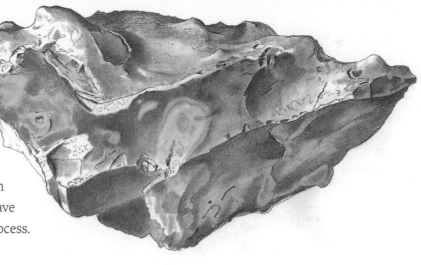

Wood

The action of water and termites over a long period has produced a very varied surface on the sawn-off log; in some places it is crumbling and in others hard and smooth and virtually intact apart from a few cracks. The weathering has produced an almost baroque effect.

By contrast, this wooden box presents beautiful lines of growth which endow an otherwise uneventful surface with a very lively look. The knots in the thinly sliced pieces of board give a very clear indication of the material the box is made of.

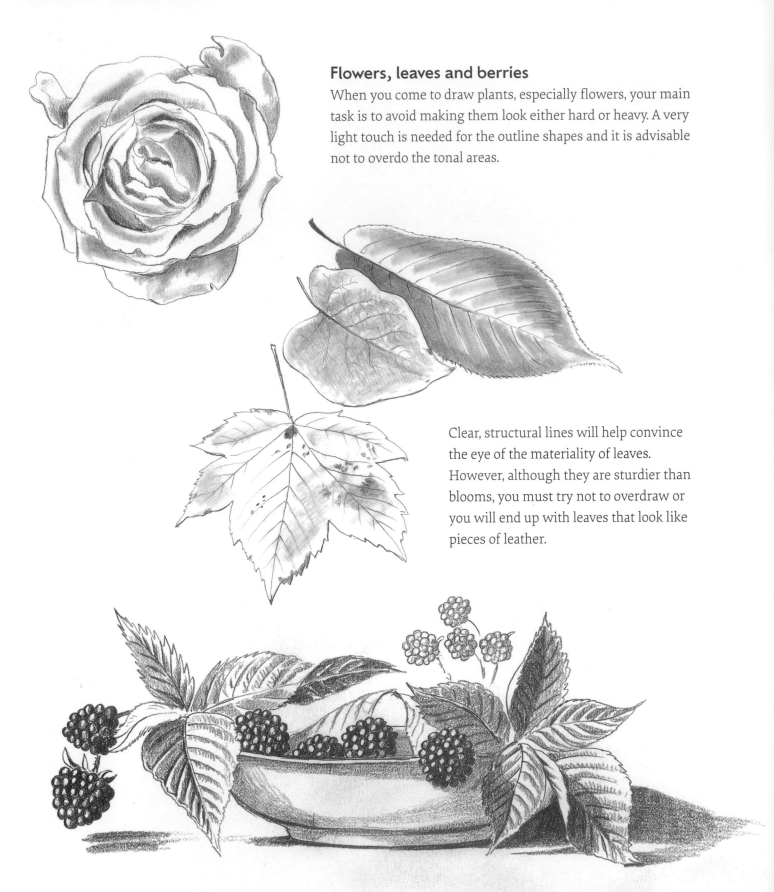

Flowers, leaves and berries

When you come to draw plants, especially flowers, your main task is to avoid making them look either hard or heavy. A very light touch is needed for the outline shapes and it is advisable not to overdo the tonal areas.

Clear, structural lines will help convince the eye of the materiality of leaves. However, although they are sturdier than blooms, you must try not to overdraw or you will end up with leaves that look like pieces of leather.

The shiny, dark globes of the blackberries and the strong structural veins of the pointed leaves make a nice contrast. The berries are just dark and bright whereas the leaves have some mid-tones that accentuate the ribbed texture and jagged edges.

Food

Food is a subject that has been very popular with artists through the centuries, and in still-life artworks it has often been used to point up the transience of pleasure and life. Even if you're not inclined to use food as a metaphor, it does offer some very interesting types of materiality.

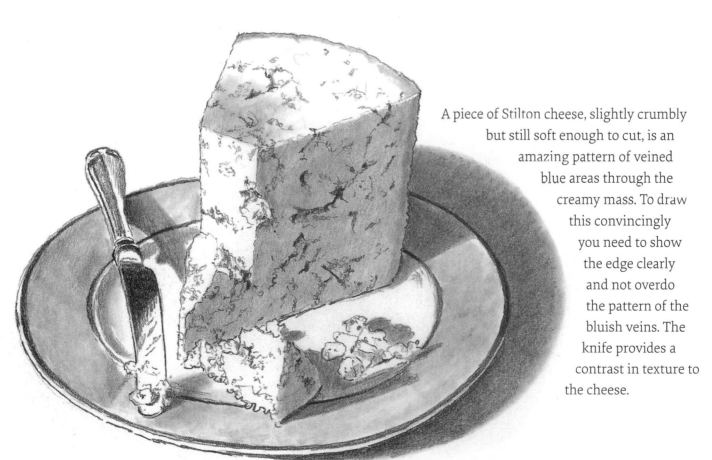

A freshly baked stick of bread that looks good enough to eat. Where it is broken you can see the hollows formed by pockets of air in the dough. Other distinctive areas of tonal shading are evident on the crusty exterior. Make sure you don't make these too dark and stiff, otherwise the bread will look heavy and lose its appeal.

A piece of Stilton cheese, slightly crumbly but still soft enough to cut, is an amazing pattern of veined blue areas through the creamy mass. To draw this convincingly you need to show the edge clearly and not overdo the pattern of the bluish veins. The knife provides a contrast in texture to the cheese.

DRAW A GLASS IN STEPS

After studying the varied textures shown on the previous pages, take some time to make a detailed drawing of an object such as this glass. Notice how the addition of a dark background in the final step enhances the delicate transparency of the glass.

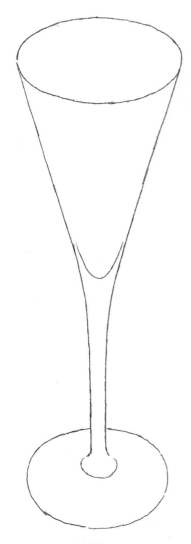

Step 1

Draw the outline of this glass as carefully as you can. The delicacy of this kind of object demands increased precision in this respect.

Step 2

When you are satisfied you have the right shape, put in the main shapes of the tonal areas, in one tone only, leaving the lighter areas clear.

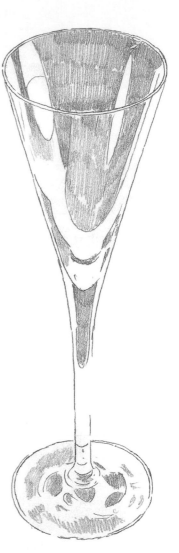

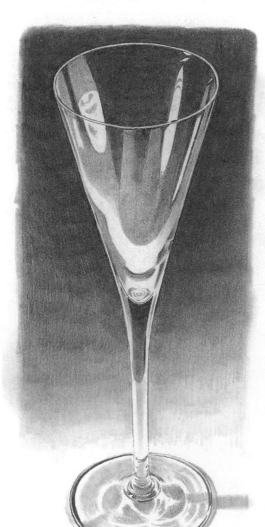

Step 3

Finally, put in the darkest tones quite strongly. Use an eraser to pick out any highlights that you have smudged; the shape and location of the highlights are key to conveying the characteristic materiality of glass.

AN EXERCISE WITH PAPER

Here is an exercise often given to art students to test their ability to observe shape and texture. Take a piece of paper, crumple it up, then put it down and draw it as accurately as you can. Soon you will realize that although you have to try to follow all the creases and facets, it really doesn't matter if you do not draw the shape precisely or miss out one or two creases. The point is to make your drawing look like crumpled paper, not necessarily achieve an exact copy.

Step 1

Draw the lines or folds in the paper, paying attention to getting the sharp edges of the creases.

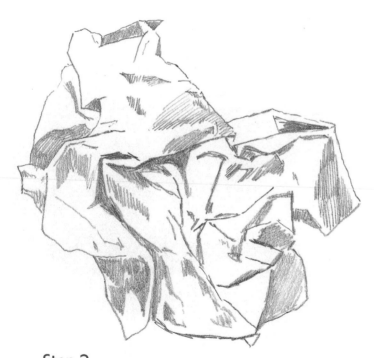

Step 2

Put in the main areas of tone. Squint your eyes to help identify these.

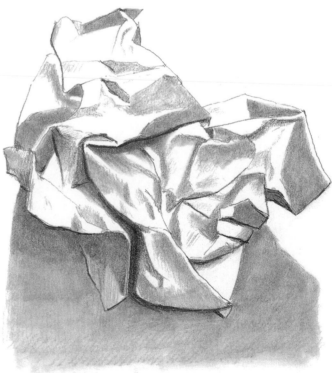

Step 3

Once you have covered each tonal area, put in any deeper shadows, capturing the contrasts between these areas. Add a shadow to the surface beneath the paper, using a stump to blend and soften your pencil marks.

USING DIFFERENT MEDIA

Taking an object and drawing it in different types of media is another very useful practice when you are developing your drawing skills. The materials we use have a direct bearing on the impression we convey through our drawing. They also demand that we vary our technique to accommodate their special characteristics. For the first exercise I have chosen a cup with a normal china glaze but in a dark colour.

Drawn in pencil, each tonal variation and the exact edges of the shape can be shown quite easily – once you are proficient, that is.

Attempt the same object with chalk (right) and you will find that you cannot capture the precise tonal variations quite so easily as you can with pencil. The coarser tone leaves us with the impression of a cup while showing more obviously the dimension or roundness of the shape. A quicker medium than pencil, chalk allows you to show the solidity of an object but not its finer details.

Although ink (left) allows you to be very precise, this is a handicap when you are trying to depict the texture of an object. The best approach is to opt for rather wobbly or imprecise sets of lines to describe both the shape and texture. Ink is more time-consuming than either pencil or chalk but has the potential for giving a more dramatic result.

Consider which drawing materials are best suited to the subjects you choose. Some materials will work to convey particular tones and textures better than others.

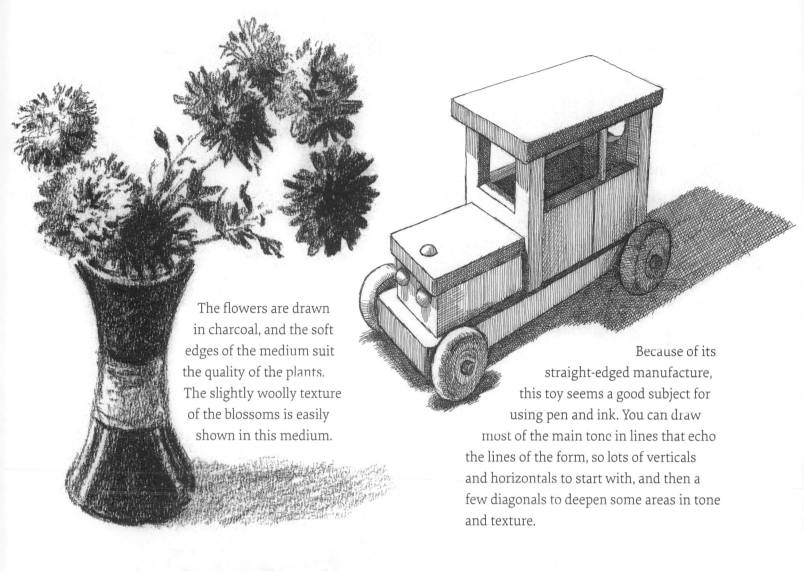

The flowers are drawn in charcoal, and the soft edges of the medium suit the quality of the plants. The slightly woolly texture of the blossoms is easily shown in this medium.

Because of its straight-edged manufacture, this toy seems a good subject for using pen and ink. You can draw most of the main tone in lines that echo the lines of the form, so lots of verticals and horizontals to start with, and then a few diagonals to deepen some areas in tone and texture.

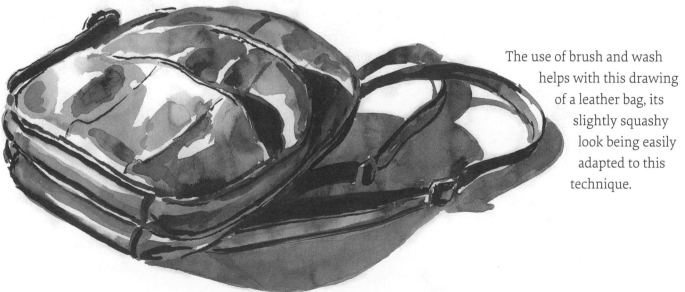

The use of brush and wash helps with this drawing of a leather bag, its slightly squashy look being easily adapted to this technique.

41

LIGHTING

The type of shadow that an object throws varies depending on the direction of the source of light. A simple way of learning about shadows is to arrange an object at various angles and note the differences. A lamp is an ideal of source of light for this exercise, enabling you to move the objects around to produce a maximum variety of shadows.

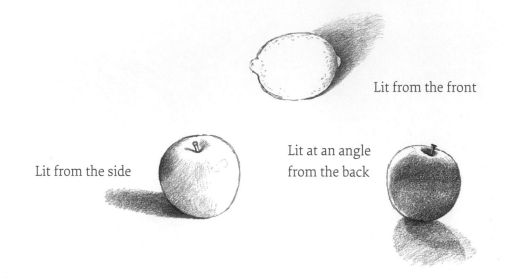

Lit from the front

Lit from the side

Lit at an angle from the back

Here, notice how the apple with the light full on it and the apple silhouetted against the light look less dimensional than the apples lit side on.

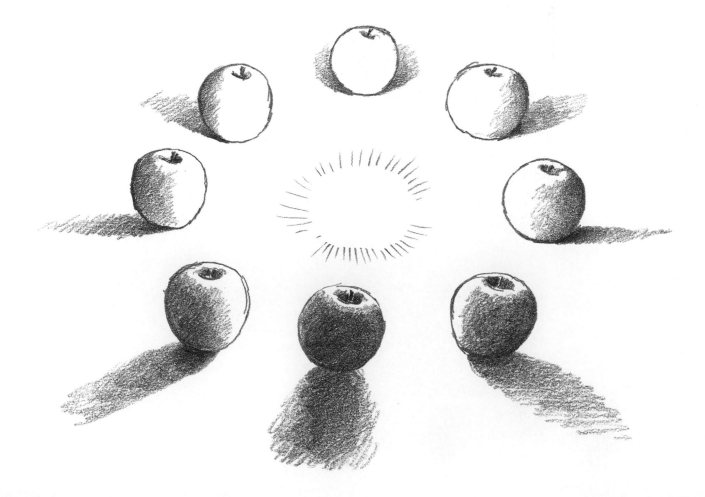

The Effects of Light

Many an art student has been put out by the discovery that the natural light falling on their still-life arrangement has changed while they have been drawing and that they have ended up with a mish-mash of effects. You need to be able to control the direction and intensity of the light source you are using until your drawing is finished. If this can't be done with a natural light source, use an artificial lighting set-up.

Lit directly from the side; this produces a particular combination of tonal areas, including a clear-cut cast shadow.

Lit from above; the result is cooler and more dramatic than the first example.

The next two pictures show the difference between the effects of daylight and of artificial light.

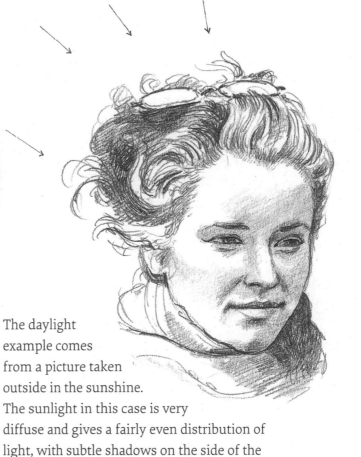

The young woman's face demonstrates the most 'normal' method of lighting an individual, with the light falling from above and to the left of her head. It results in what is ordinarily expected of a portrait; the face is well defined but quite gently lit. It is a classic three-dimensional head viewed in a clear light.

The daylight example comes from a picture taken outside in the sunshine. The sunlight in this case is very diffuse and gives a fairly even distribution of light, with subtle shadows on the side of the head that is facing away from the sun.

A STILL LIFE OF FRUIT

Drawing a still life of fruit is a great way to practise the skills you have learned so far. Study the forms of the fruit and their textures, and consider how you will apply tone to show the light falling over them and the areas of shadow. First collect a few pieces of fruit that appeal to you and arrange them on a surface so that some of them are behind others. I've chosen a bunch of grapes, which I've placed further back than the rest of the fruit, and three tomatoes, an apple and a nectarine.

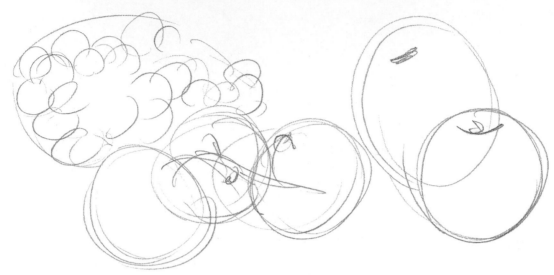

Step 1
Start off by making a very loose sketch to get some idea as to how the arrangement looks. This drawing is not precise and is really to give you a basis on which to start drawing more definitely.

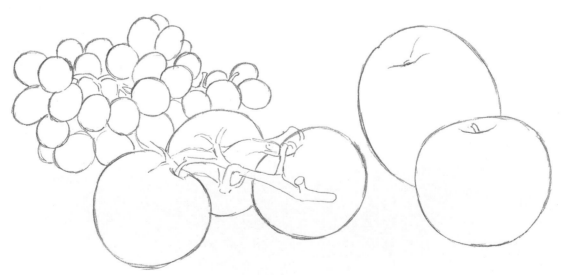

Step 2
In the next stage, draw the shapes of each piece of fruit quite concisely, making sure that each is as accurate as possible. This is the time to do any correcting and erasing, with the hope that it won't then be necessary in any later stages.

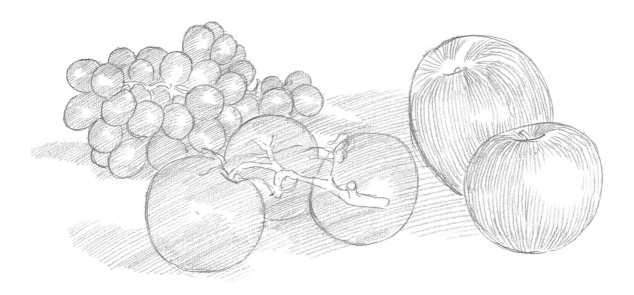

Step 3

Then carefully put in the areas of tone, all in a uniformly light tone. With the larger pieces of fruit, draw the tonal area with your pencil strokes following the form of the fruit.

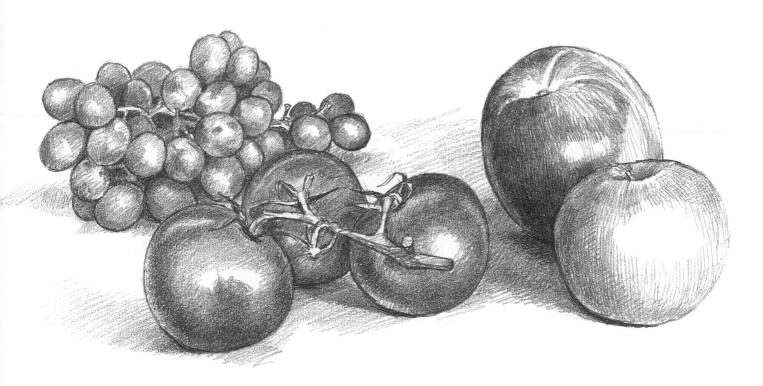

Step 4

Now all that is needed is to work over all the tonal areas until the darkest to lightest values make sense. One way to see how correct your tonal values are is to half-close your eyes when you look at the still life, which will help you to see tone rather than colour. If you have taken the tone over the highlighted areas by mistake, you can bring those back by using an eraser to re-establish them.

A STILL LIFE OF PLANTS

A plant still life can be either formal or informal – for example, a vase of flowers usually gives a more formal effect than plants in a flowerbed or window box. The one shown here is a large box of various herbs. Notice how the soft clumps of leaves are suited to a looser drawing style than the fruit on the previous pages.

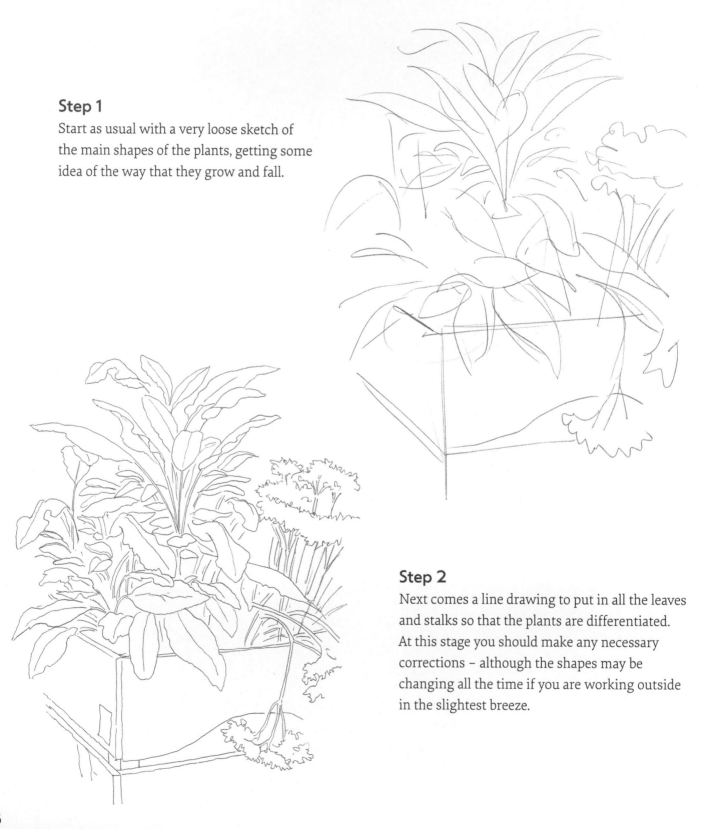

Step 1

Start as usual with a very loose sketch of the main shapes of the plants, getting some idea of the way that they grow and fall.

Step 2

Next comes a line drawing to put in all the leaves and stalks so that the plants are differentiated. At this stage you should make any necessary corrections – although the shapes may be changing all the time if you are working outside in the slightest breeze.

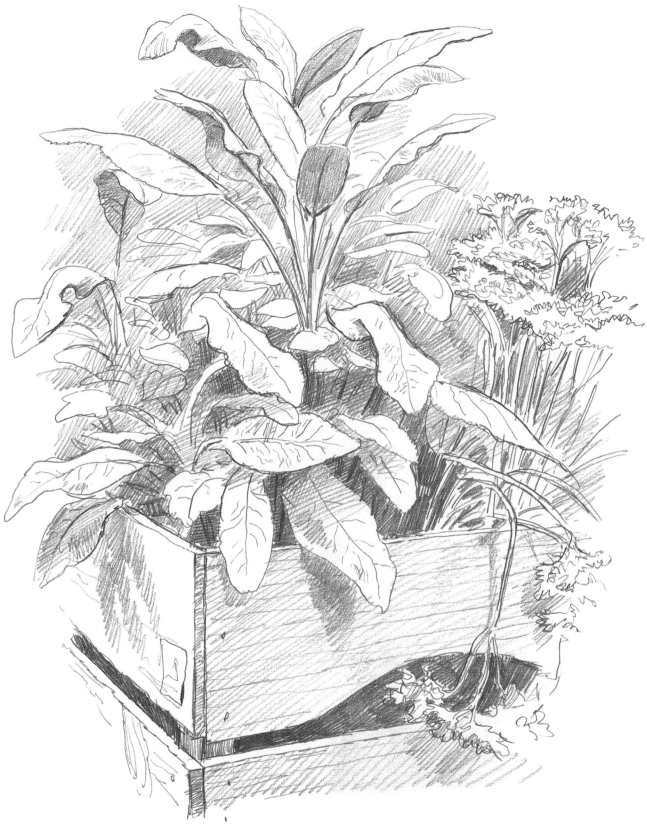

Step 3

Putting in shading will give some depth to the plants. The darkest shadows go in first, then gradually build up the different tonal areas until the result looks fairly realistic. There is no need to draw the smaller leaves exactly – just put them in with an expressive scribble. The contrast between the box and the leaves helps to make the leaves look softer and more fragile.

DRAW A HEAD AND FACE

So far we have looked at some diagrammatic drawings of the head (see page 17) and a textural rendition of hair (see page 29). This exercise may seem daunting, but don't expect to create a perfect likeness on your first go. Take it step by step and ensure you follow the proportions shown in steps 1 and 2. If someone you know will sit for you for an hour you can draw their face, but if this is difficult, simply position yourself in front of a good-sized mirror and draw your own.

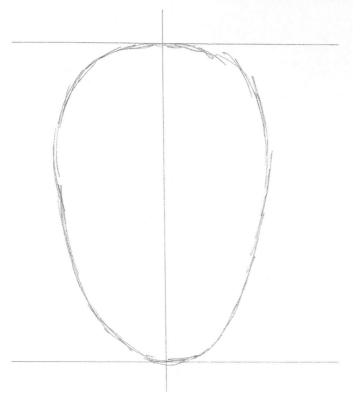

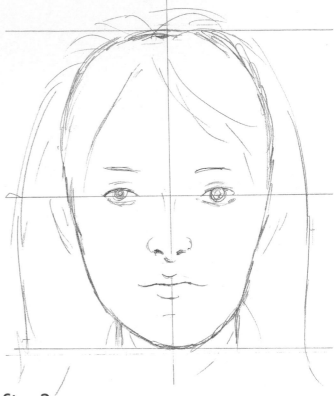

Step 1

To start with you need to draw a straight-on, full-face view, so that you can understand the proportions of the human head. Make a mark at the top of the page to indicate where the top of the head is going to be, and another where the point of the chin will go. Don't make the distance between these two points bigger than the size of the head, although it doesn't matter if it is a bit smaller. Now draw a line straight down to join the top mark to the bottom. This indicates the centre of the head vertically. All the shapes you are going to draw should be evenly balanced either side of this line.

Looking carefully at the shape of the head in front of you, whether your own or your model's, have a go at drawing the oval shape of the whole head – and I mean the whole head, not just the face. You'd be surprised how many beginners draw the head as though there is nothing much above the hairline.

Step 2

Draw a horizontal line halfway down the head to show the level of the eyes. Mark in the position and shape of the eyes on this line. The distance between them is the same as the length of the eye from corner to corner.

Then mark in the end of the nose, about halfway between the eyes and the point of the chin. Draw just the nostrils and the bottom edge of the nose. Next draw the line of the mouth, which is slightly nearer the nose than the chin – it is usually positioned at one-fifth of the whole head length from the bottom of the chin. Draw the shape between the lips, then, more lightly, put in the shape of the upper lip below the nose and the fold under the lower one, not the edge of the lip colour.

Mark in the hair, the position of the ears, if they can be seen, and the eyebrows. The tops of the ears and the eyebrows are at about the same level. So now you have the basic head with its features put in.

Step 3

The next stage is to draw all the features and the hair, correcting any mistakes as you go. Look at the thickness of the eyebrows and note that the shape of the inner corner of the eye is different to that of the outer. If the eyes are looking straight at you, the iris is slightly hidden by the upper eyelid and usually touches the lower one. You can't see a great deal of the ears from this angle, but try to get the shape as accurately as you can.

The most important areas of the nose are the under part and the shape of the nostrils. There are usually marks that you can draw lightly to indicate the area where the nose is closest to the eyes and there may be a strong shadow showing the bonier part of the nose – but mark it in only lightly, or it will look like a beak.

The mouth is a bit easier, but remember that the strongest marks should be reserved for the line where the lips meet; if you make the edges of the lip colour too strong it will have the effect of flattening the lips. There is usually a strong fold under the lower lip which can be more defining of the mouth than the edge of the colour.

The outline of the jaw and cheekbones is important to show the characteristics of the face in front of you. If you make the jaw too large or small it will look clumsy or weak respectively, so take your time to get this right.

The hair is also important, especially where it defines the shape of the skull underneath. If it's too big your model will look like an alien, while if it's too small the head will appear to lack enough space for brains.

Step 4

Now you can start to mark in the shading on the face and hair, putting it all in at the same strength. There will usually be light coming from one side, and in my example the left side of the face is in some shadow and the right side is in more light. This stage is where the projecting features such as the nose, eyebrows and mouth start to show their form.

Shade the hair in the same way, but take the marks in the direction that the hair grows. If the hair is dark, put another layer of tone everywhere except where the light shines strongly on it.

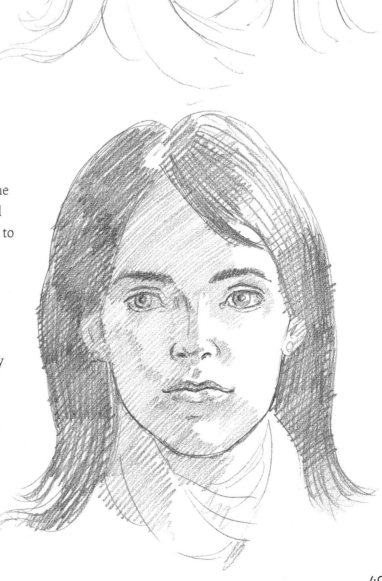

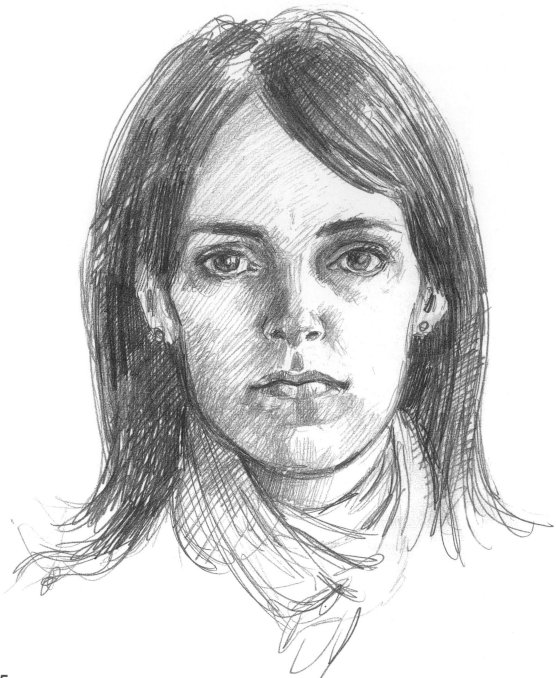

Step 5

In the last stage, draw in the very darkest tones and the variety of tones over the whole head. You may have to darken the hair quite a bit, but remember that only the deepest shadows should be black.

Mark in the edges of the eyelids carefully. The edge of the upper lid is much darker than the lower, partly because it is facing downwards and partly because the eyelashes cast a shadow. The pupil of the eye is dark, but usually you can see a bright speck which reflects the light in the room, which gives the eye its sparkle. Note the shadow around the eye near to the nose.

The shading around the nose and the mouth should be done very carefully – if you make it too dark the result will look a bit cartoonish. Try to let the tones melt into each other so that there are no sudden changes. The shading on the sides of the jawline are often darker than on the point of the jaw because the light is reflected back up under the chin. Keep stopping to look at the whole picture to see if you are getting the balance of tone right. Don't be afraid of erasing over and over again to get the right effect – the result may end up a bit messy, but you will have learnt a valuable lesson about form in a drawing.

PROPORTIONS OF THE FIGURE

Before you leap into your first figure drawing, pause to study the proportions of the human figure. These are not the precise proportions of every individual but represent an average.

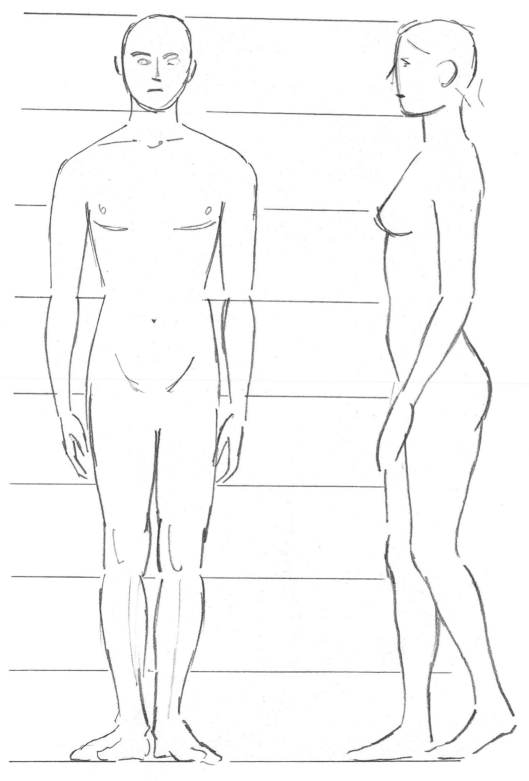

The height of the average adult – male or female – is approximately seven-and-a-half to eight times the length of their own head, measured from top to bottom. Note how the figures shown here are the same height; in reality the female is probably shorter than the male but the proportion of head to height remains the same. The widest area of a man is usually his shoulders, whereas in a mature woman it is usually the hips. Generally, but by no means universally, the male is larger than the female and has a less delicate bone structure.

Proportions of Children

The proportions of children's bodies change very rapidly and because children grow at very different speeds what is true of one child at a certain age may not always be so true of another. Consequently, the drawings here can only give an average guide to children's changes in proportion as they get older.

The thickness of children's limbs varies enormously but often the most obvious difference between a child, an adolescent and an adult is that the limbs and body become more slender as part of the growing process. In some types of figure there is a tendency towards puppy fat which makes a youngster look softer and rounder.

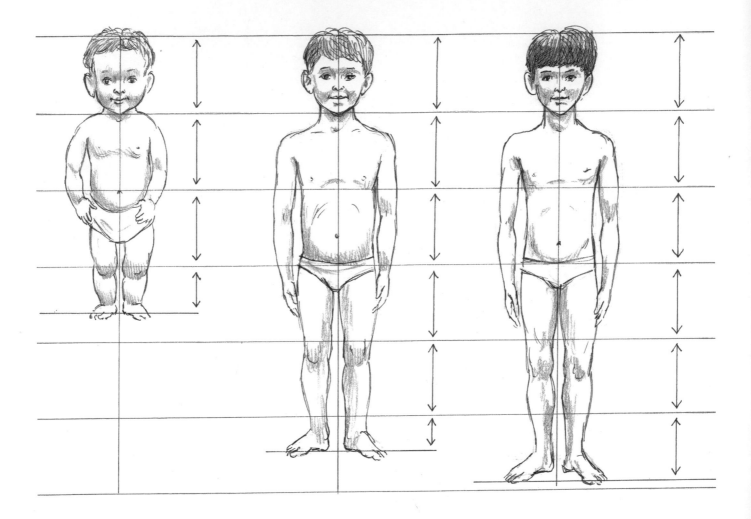

At the beginning of life the head is much larger in proportion to the rest of the body than it will be later on. Above left I have drawn a child of about 18 months old, giving the sort of proportion you might find in a child of average growth. The height is only three and a half times the length of the head, which means that the proportions of the arms and legs are much smaller in comparison to those of an adult.

At the age of about six or seven, a child's height is a little over five times the length of the head, though again this is a bit variable. At about 12 years, the proportion is about six times the head size. Notice how in the younger children the halfway point in the height of the body is much closer to the navel, but this gradually lowers until it reaches the adult proportion at the pubic edge of the pelvis where the legs divide.

FORESHORTENING

We rarely see the body so neatly arranged as in our diagrams of proportion;
we mainly view people from all sorts of angles, often with their limbs foreshortened.
The following illustrations show some proportions that commonly occur.

Here is someone lying down, seen from the feet end. Because they are closest to the viewer, the feet will appear much larger than we would usually expect. Here the length of the foot is almost as long as the head and torso of the figure.

The legs from the ankle to the hips are the main area of the body on show, appearing more than twice as large as the head and torso. The legs and hips are also much thicker than the upper parts of the figure.

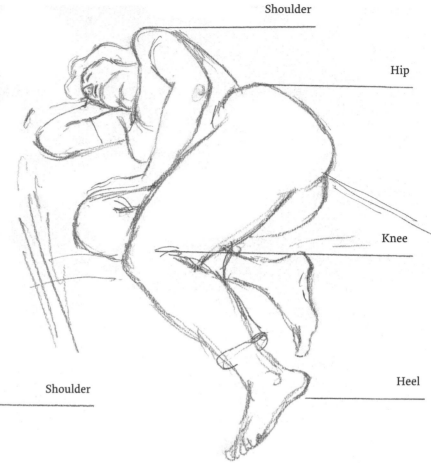

Shoulder

Hip

Knee

Heel

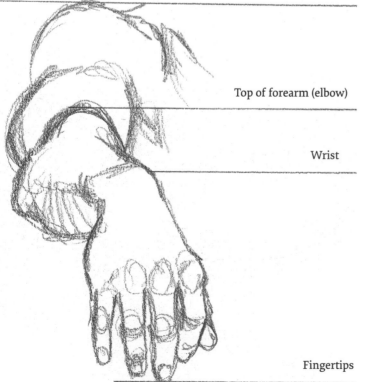

Shoulder

Top of forearm (elbow)

Wrist

Fingertips

On the arm the same thing occurs; when we're looking from the hand, the shoulder, upper arm and lower arm appear to be no longer than the hand. In this extreme view, the main length of the arm has been reduced to almost nothing, while the hand appears to be enormously enlarged.

DRAWING SIMPLE FIGURES

For looking at the human figure more extensively, you will find that a good supply of photographs of people in action can be very useful. While the best drawings are done from life, using photographs, especially if you have taken them yourself, is not a bad substitute.

First of all, limit yourself strictly to the simplest way of showing the figure, which is almost like a blocked shape with a line through its length. Try to do a few drawings like this, spending just 3–4 minutes on each one and making your lines fluid and instantaneous, even if at first the results look terrible. All artists start like that, and only time and repeated practice effect a change.

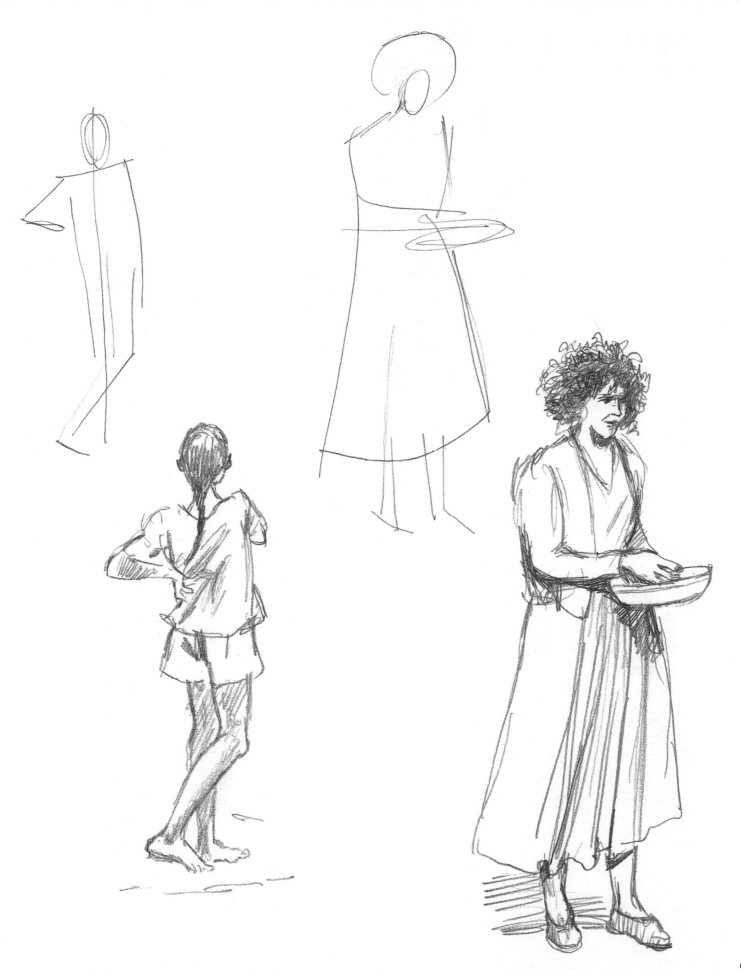

EXPRESSIVE FIGURES

Here we are still looking at the human form, but in poses that are more expressive. The four figures on this spread are not even shown in full, because my interest is in the gesticulating hands. Once again these might be easier for you to draw from photographs that have frozen the moment.

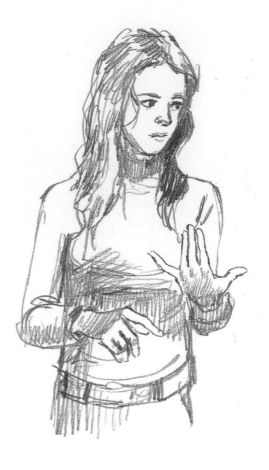

Block these in to start with as you did before, but pay particular attention to the position of the hands. One girl looks as if she is ticking off points on her fingers, one man is gesturing to draw attention to something, the other girl is in the process of combing her hair and the last man is sitting down to draw something... perhaps you!

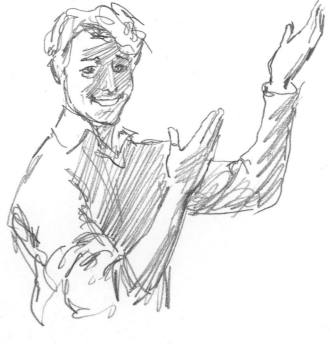

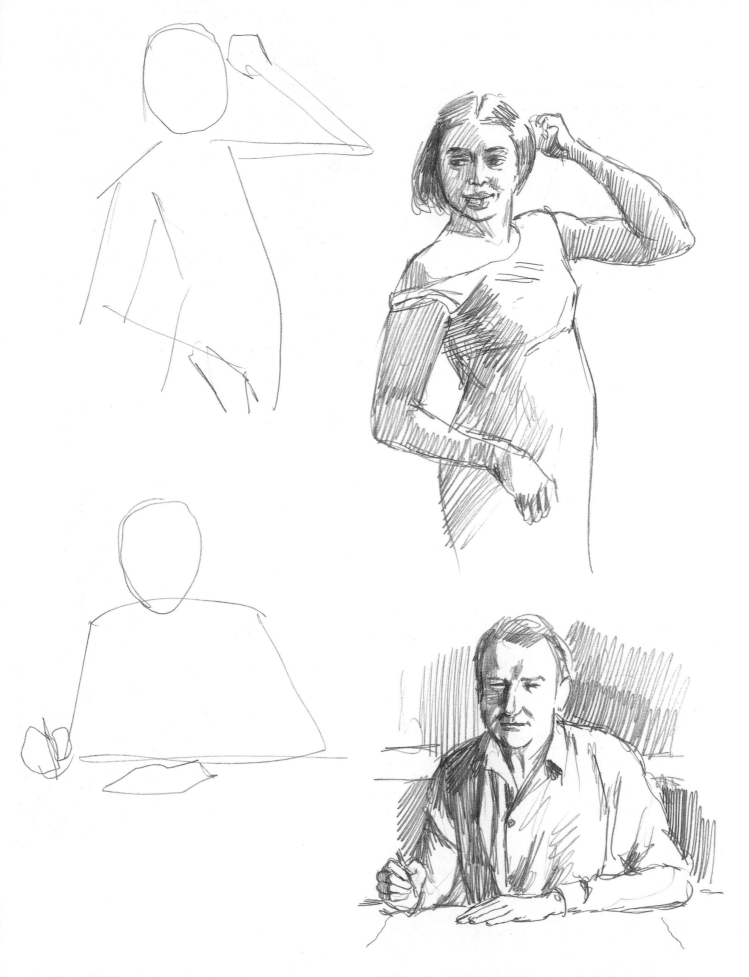

THE HEAD: PRACTICE

When it comes to making a portrait, it is of course the head and face that will identify your sitter above all else. Studying the overall structure of the head from various angles gives us a thorough understanding of the appearance of our subject and is key to getting a good likeness. Notice how the angle of the head affects the appearance of the features, sometimes quite dramatically.

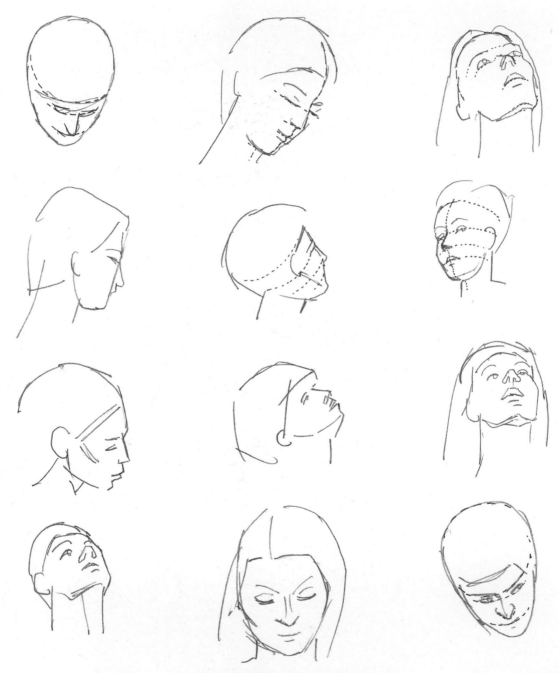

Some of these heads are seen from slightly below and some from slightly above. The former show the projection of the jaw and the nose seems to be shorter and almost blocking out some of the eye; the latter show more of the top of the head and the mouth tends to disappear under the projection of the nose.

These drawings are all done as blocked-out shapes, emphasizing the three-dimensional quality of the head and getting across the idea of the whole shape, not just the face.

These drawings show the same set of heads as on the facing page, but this time with the hair and features put in more naturally. Notice how the shadows on the faces give an extra dimension, not only to the form but also to the expressions. Try to draw as many different versions of heads as you can, because it will improve your ability to draw portraits in more depth. Draw from life whenever possible, resorting to photographs if need be.

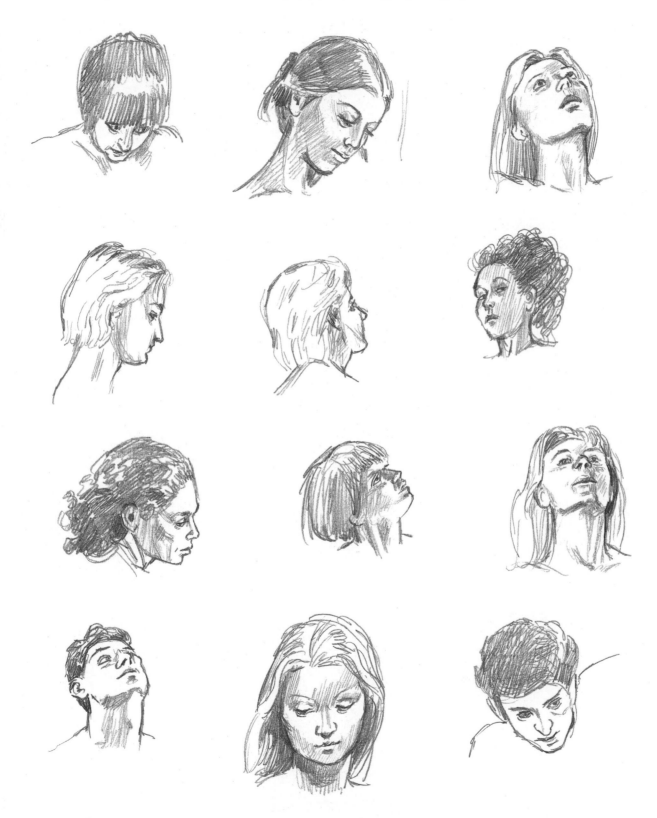

OBSERVING HEADS AND FACES

The variety to be found in the features of the face is astounding, and this is what helps us to identify others and judge their age. When it comes to drawing you need to go beyond recognition and study peoples' face shapes and features in depth.

Children

Children's heads don't match the proportions of an adult head. The greatest difference is the size of the cranium in relation to the lower jaw, but also the eyes are more widely spaced than in an adult and the cheeks are usually rounder. All the features fit into a much smaller space, and of course there are hardly any lines on the face.

These drawings of a little girl of four or five years of age, viewed from above and below, show the soft rounded cheeks and small snub nose which are fairly typical of the age group.

The little boy is a bit older but doesn't have a fully grown jaw yet, and his eyes and ears look much larger in relation to his nose and mouth than they would in an adult.

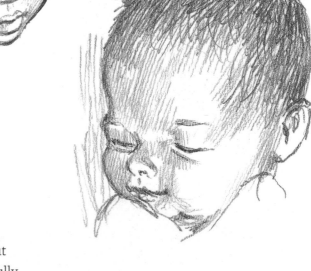

The little baby is an even more extreme shape, having a much larger cranium than face, with all her features being close together in the lower part of her head.

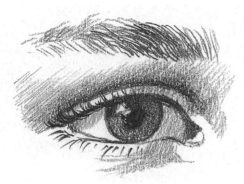

Ageing

Now let's look at the effect of age on the eye. This is quite important, because it's the eyes that mainly give us the clues as to how old someone might be. The first eye is of a little boy of six and looks as big and lustrous as any young woman's might. There are hardly any lines around the eye.

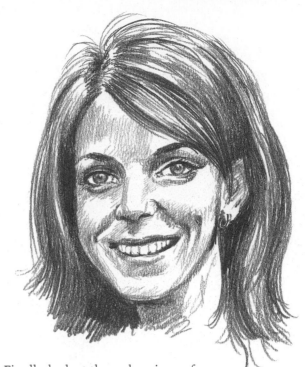

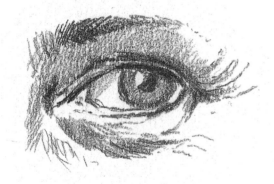

Next we have someone of middle age. Although the eye is still quite lustrous there are lines around the eye socket that give you some idea of the age.

Finally, look at these drawings of a young woman at her peak and one of an old man – my youngest daughter and myself. See the difference in the quality of the hair, on the one soft and shiny, the other white and sparse. Then look at the surface of the skin. Although my daughter is grinning widely she has very few lines on her face and her eyes are very clear. My own skin is furrowed with lines of all kinds, especially around the eyes and on the forehead. The cheeks look more hollow and the mouth is defined only by its edge. I appear to be staring intently; that's because I am of course drawing myself in a mirror.

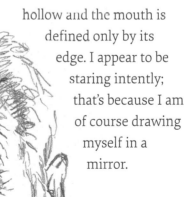

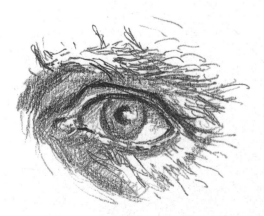

This is the eye of an elderly person, with all the multifarious lines etched into the skin and the straggly eyebrows.

WHOLE PERSON PORTRAIT

This exercise will seem like a reward for all your hard work so far on the human figure – drawing a complete portrait of someone who will be prepared to pose for you for a while. I took as my model my six-year-old grandson, who is not easy to keep in one position, but I put him in front of the television to watch a film that I knew would interest him so he sat for a little longer than usual. That in itself is a lesson – make your models comfortable and happy and you will get more time to draw them!

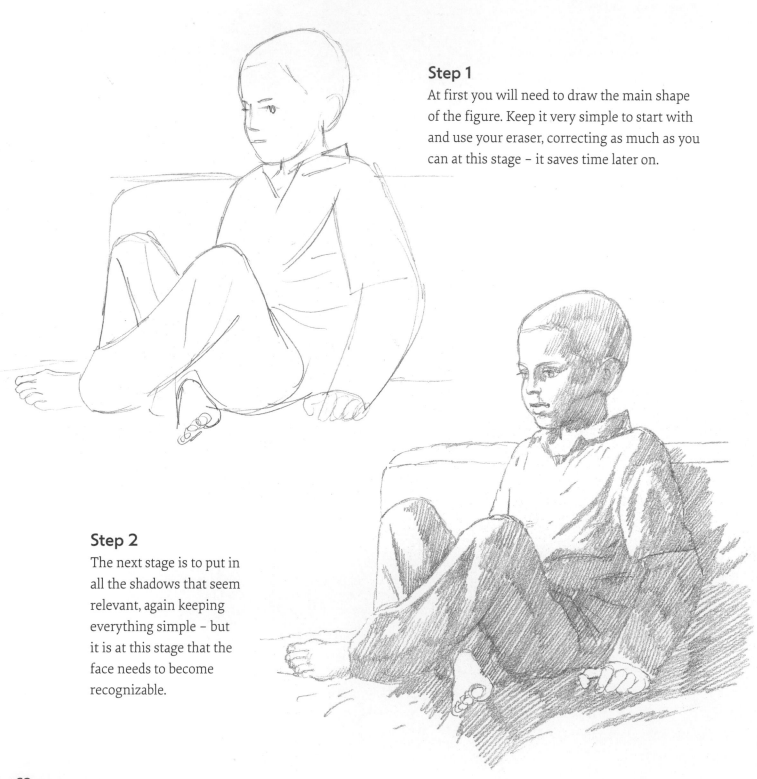

Step 1

At first you will need to draw the main shape of the figure. Keep it very simple to start with and use your eraser, correcting as much as you can at this stage – it saves time later on.

Step 2

The next stage is to put in all the shadows that seem relevant, again keeping everything simple – but it is at this stage that the face needs to become recognizable.

Step 3

Once you are sure everything is the right shape and in the correct proportion, begin to work into the picture to make it come to life. Take great care over the head, because this is where the picture becomes a portrait of a particular individual rather than of just anyone. This is not so difficult as it sounds because we all have this marvellous ability to recognize human faces, so you will automatically draw the features correctly if you really pay attention. Build up the tones in such a way as to stress the softness or hardness of the form.

Good luck in your efforts – even if you are not successful this time, the practice will enable you to do a lot better on the next occasion.

ONE-POINT PERSPECTIVE

As you start to take on larger subjects, a knowledge of the rules of perspective will help you to draw furniture, rooms, buildings and more. Take your time to study and copy the diagrams shown here. One-point perspective is the simplest form of perspective and often the only one you need to know when you're drawing subjects from close quarters.

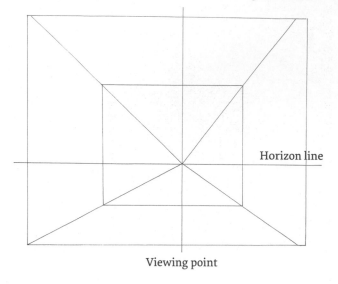

Horizon line

Viewing point

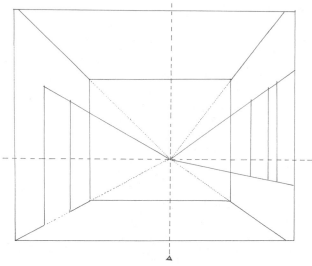

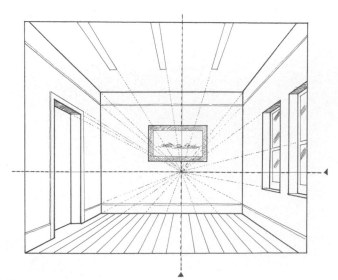

To start a one-point perspective drawing, for example of a room, you first need to establish a horizon line, or eye level. Perpendicular to that, near the middle of the horizon, a vertical line represents your viewing point. Then, to construct the room, you need a rectangle with the two lines crossing near the centre of it – don't place them exactly in the middle, or it will look a bit too contrived. Now draw lines from the centre point where the horizon and vertical meet to pass through the corners of your rectangle.

From this point you can now construct lines as shown, to place the position of a door on one side wall and two windows on the opposite wall.

If you imagine yourself in an empty room, standing not quite in the middle, you might see something like this diagram, based on the perspective lines you've just established.

Notice how the vertical line indicates your viewing position and the horizontal one your eye level. All the floorboards seem to slope towards the centre point, known as the vanishing point. The lines of the skirting boards and the cornice rail on the walls to each side all slope towards this centre point also, as do the tops and bottoms of the door and the windows. In other words, except for the lines which are vertical or horizontal, all lines slope towards the centre point – which is why it is called one-point perspective.

This diagram gives a good idea of how you can set about constructing a room that appears to have depth and space. Now go and stand or sit in a room of your home and see if you can envisage where imaginary horizontal and vertical lines representing your eye level and viewing position cross; this is the vanishing point for the perspective, to which all the lines that aren't vertical or horizontal will slope. Even the furniture is included in this as long as it's square on to the outlines of the room.

TWO-POINT PERSPECTIVE

When you draw outdoors you need an extra measure of perspective, because you're dealing with much bigger spaces and with large objects such as buildings and cars. This means that you need to use two-point perspective, which will enable you to construct buildings that look convincing.

In this diagram you can see that there is, as usual, an eye level or horizon line. This time you need to have two vanishing points as far as possible from the viewing point, which is near the middle.

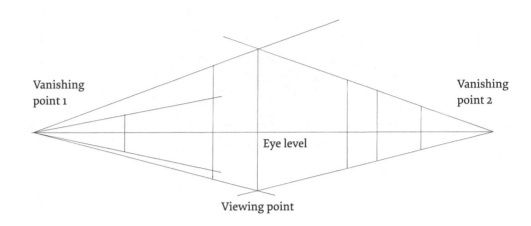

Every line in the following picture slopes towards one or the other of these vanishing points. In this way you can produce a landscape with buildings that appear to have bulk and weight.

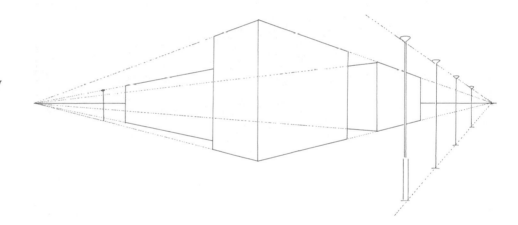

Notice how the lamp-posts appear to become smaller as they recede from your point of view. The tops and bottoms of the posts are in line, and all the rooflines of the buildings can be joined in straight lines to one of the vanishing points. The same applies to all the windows, doorways and pavements. The corner of the nearest building is on the viewing vertical and all the other parts of the buildings appear to diminish as they recede from this point.

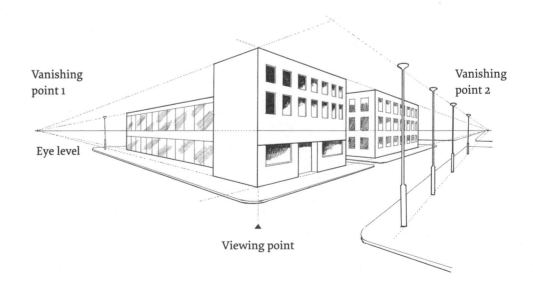

DRAWING AROUND THE HOUSE

Your knowledge of perspective will help in this exercise, which involves selecting and drawing various views around your house or flat. Try drawing small areas of the rooms from different angles and from both a standing and sitting position to give you different eye levels. In my examples, some views are quite restricted and others more expansive, but they demonstrate that even in your own house you'll find many possible subjects for a drawing.

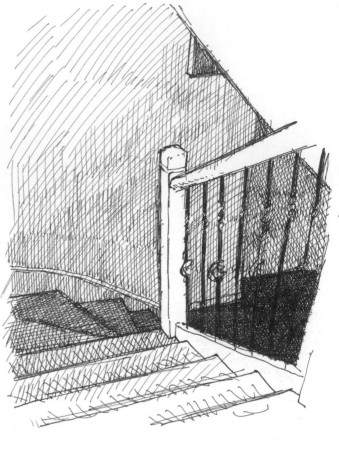

My first view was of an open sitting area at the back of the house (below). The perspective is shown mostly in the lines of the floorboards and in the shapes of the dresser and window. The cupboards and chairs give scope to achieve a three-dimensional effect to add to that given by the perspective.

The next area I chose (above) was tricky because it was halfway up the stairs and the perspective view was slightly unusual. One way to check out your own basic drawing is to take a photograph and compare the angles on the photograph to those in your drawing. The top end of the stairs was well lit, while the bottom stairs in the hall were much darker in comparison. This helps to give some feeling of depth to the composition, with the banister rail sharply defined against the gloom.

66

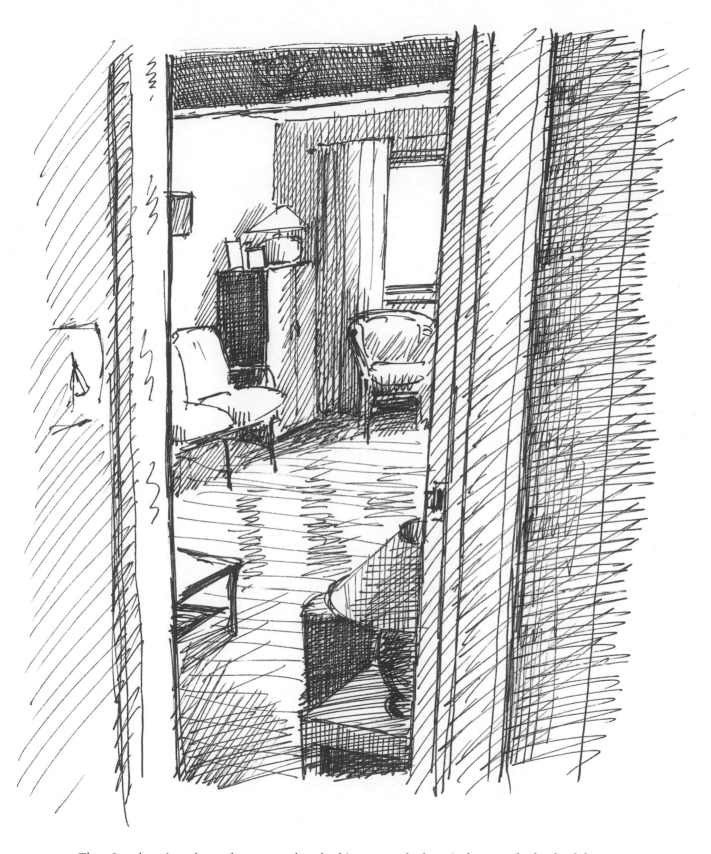

Then I took a view through an open door looking towards the windows at the back of the house. I could mainly see bits of chairs and tables, with the bright light of the window seen through the dark surround of the door jamb. This always makes for an intriguing quality in the picture because it seems to be revealing a secret view.

This view is of an inner room with a woodburning stove at the centre and some furniture and shelves glimpsed either side. It is a straight-on portrait of the stove, really, which is quite an interesting thing in itself.

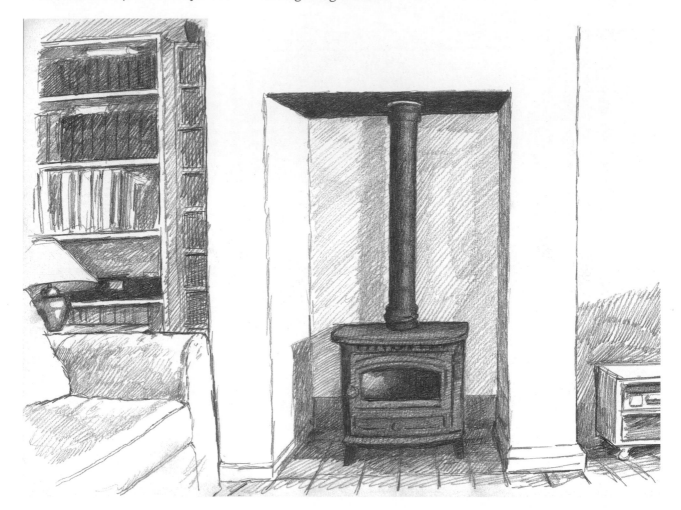

Next, moving in close to some objects in a room, I chose to draw the remains of breakfast on a large table, with a bowl of fruit and the tops of chairs around the edge of the table. The interesting thing about this is that it suggests a narrative of the ongoing life of the people inhabiting the house.

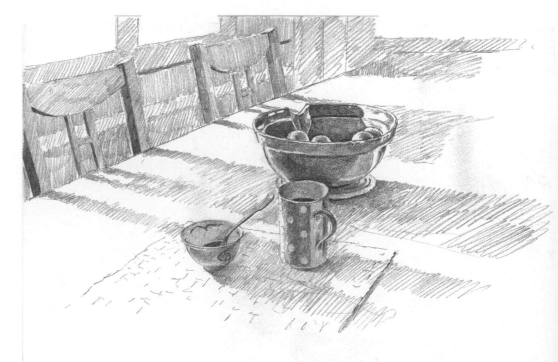

Here I have made a perspective diagram to show how the construction of the scene gives more depth to the picture of my kitchen below.

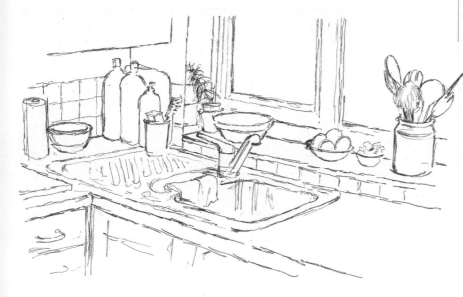

This is the view of the sink and all the paraphernalia surrounding it, as in most kitchens. You will often find interesting accidental still lifes in the kitchen, especially if it is not too tidy!

Here the perspective diagram shows how the construction of the drawing below is in fact relatively simple.

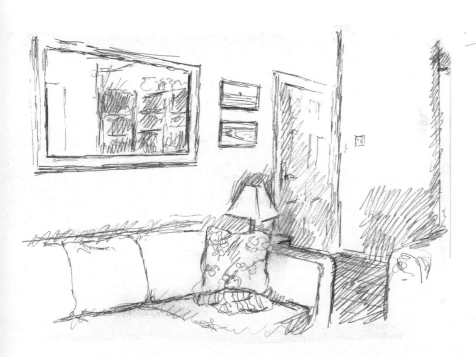

This drawing is a view of a sitting area with a mirror on the wall and the corner of a sofa with a door behind it. It isn't highly significant, but there is a small amount of perspective to be observed in the shapes of the mirror and the pictures on the wall.

AN INTERIOR IN STEPS

When you have explored your living areas and made a few sketches and perspective diagrams, choose one room to draw in more detail. Choose your viewpoint carefully so that you can maintain it comfortably, because drawing an interior can take some time.

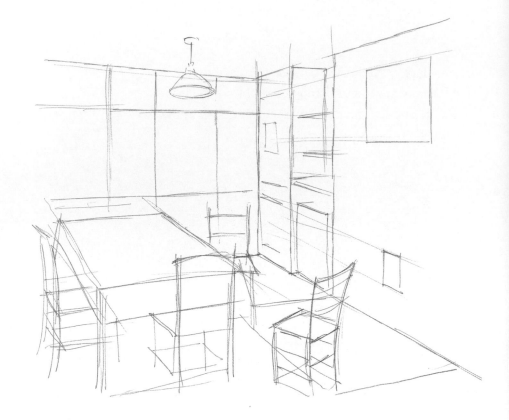

Step 1

First of all, look at this initial sketch of an interior. It will be immediately obvious to you from your studies so far that this scene is using perspective lines to construct the drawing.

Step 2

The next diagram shows perspective lines laid over the sketch to help verify my view of the room. You will find that the hardest parts of your own room to see properly are those at the periphery of your vision, in which there is often some slight distortion that would look odd in the drawing. You may have to correct or ignore some of the apparent image at the very edge of your vision.

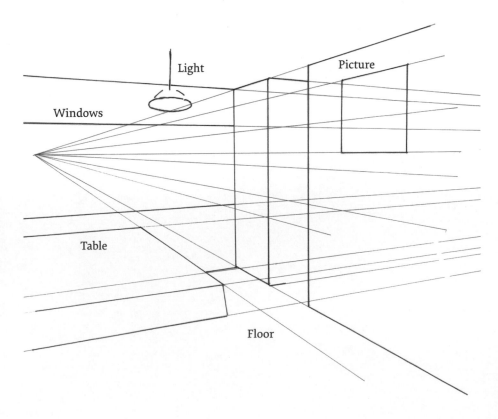

Step 3

Once you've constructed a sketch that you think holds the image correctly, begin to put in the main outlines of the room and furniture within your field of vision. However, if there are any complicated pieces of furniture or objects that make things more difficult, remove them from view or simply leave them out of your drawing.

All artists learn to adjust the scene in front of them in order to simplify it or make it more interesting and compositionally satisfying; you can see this in the topographical work of Turner, Canaletto or Guardi, for example. The lines of perspective should enable you to get the proportions of the objects in the scene accurate.

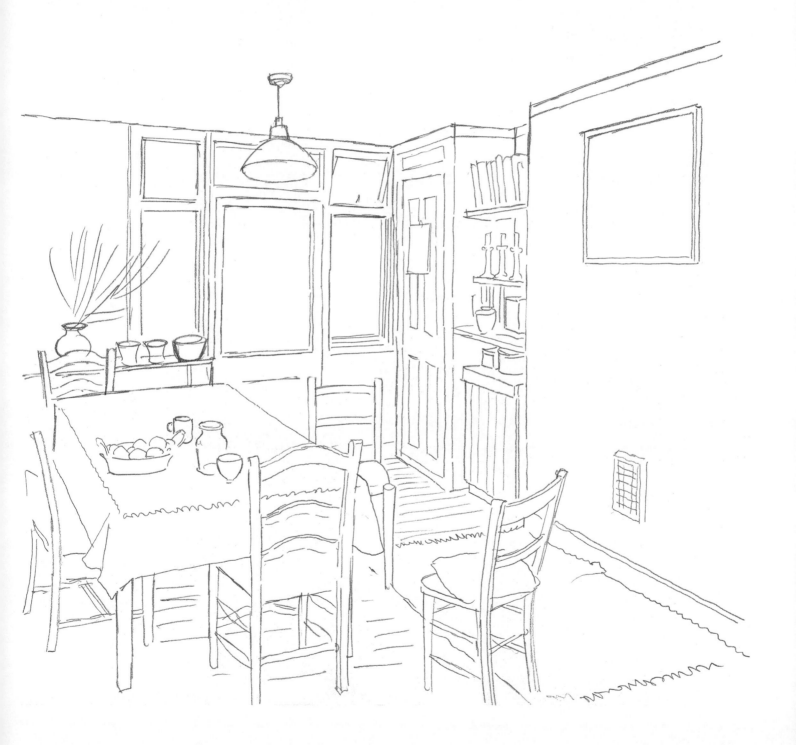

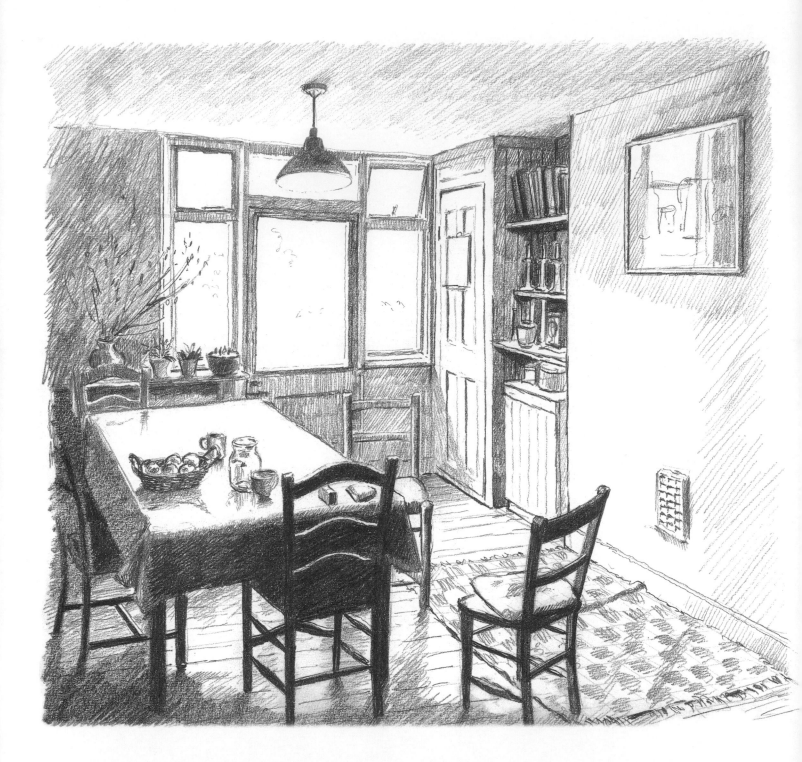

Step 4

You can then work on the tonal values of the scene to give it atmosphere and depth. If you have to leave it and come back later, check that the furniture hasn't been moved and that the angle of light is similar to the time before – if the weather is sunny and you try to resume at a different time of day, you may find the lights and darks very differently placed. The lighting in my scene is partly from the windows and partly from the overhead electric light. Notice how I have built up the tone to a strong black in the chairs nearest to my viewpoint.

FRAMING A VIEW

To begin to draw landscapes, you need a view. Look out of your windows. Whether you live in the countryside or in the town, you will find plenty to interest you. Next go into your garden and look around you. Finally step beyond your personal territory, perhaps into your street. Once we appreciate that almost any view can make an attractive landscape, we look at what lies before us with fresh eyes. The views shown here are of the area around my home.

When I look out of the window into my garden, I see a large pine tree of the Mediterranean type. It is a graceful tree and obscures most of the rooftops of the houses backing onto the garden. The window frame usefully restricts my angle of vision so that I have an oblique view of the left-hand fencing with its climbing ivy. Across the back of the garden is a fence with some small bushes under the tree. Plants grow right under the window and their stalks cut across my view. Apart from a few details of the house behind ours, this landscape is mostly of a large tree and a fence, and a few smaller plants.

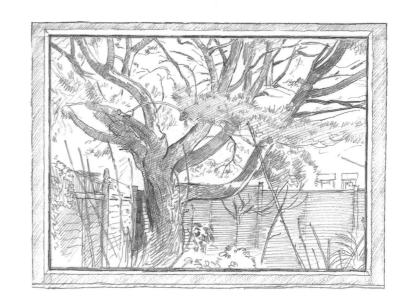

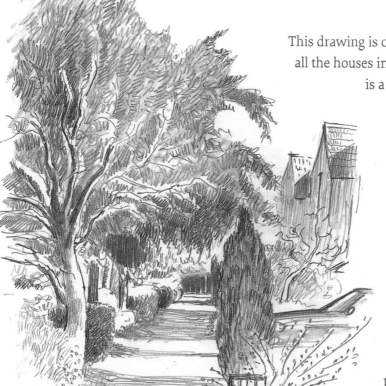

This drawing is of the view from my front gate. Because all the houses in my road have front gardens and there is a substantial area of trees, shrubs and grass before you reach the road proper, the scene looks more like country than suburb. We see over-hanging trees on one side and walls, fences and small trees and shrubs on the other, creating the effect of a tunnel of vegetation. The general effect of the dwindling perspective of the path and bushes either side of the road gives depth to the drawing. The sun has come out, throwing sharp shadows across the path interspersed with bright sunlit splashes. The overall effect is of a deep perspective landscape in a limited terrain.

73

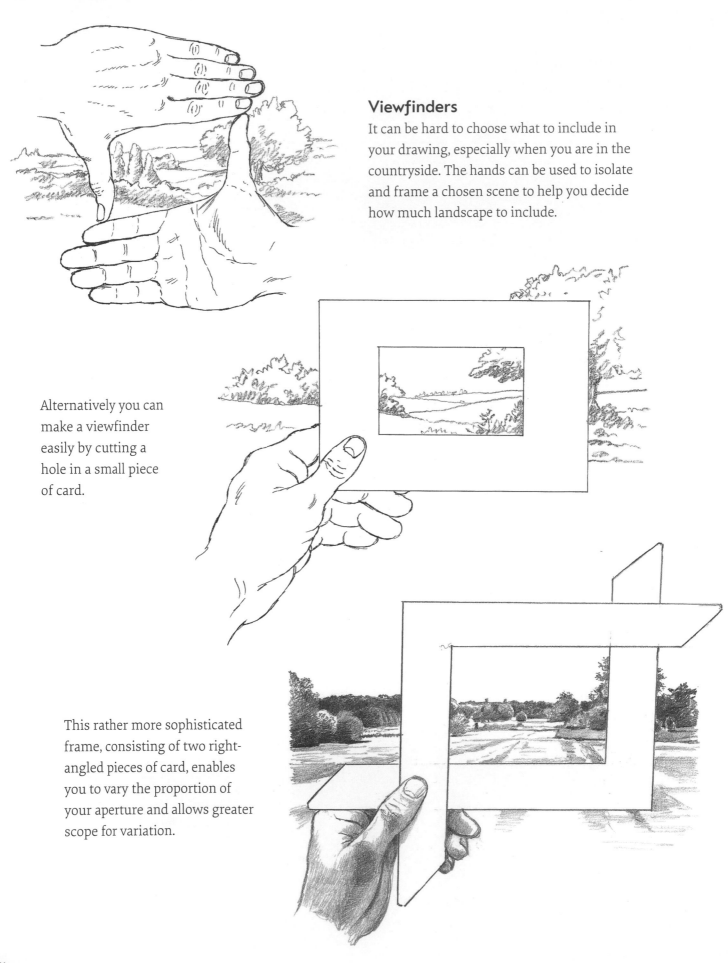

Viewfinders

It can be hard to choose what to include in your drawing, especially when you are in the countryside. The hands can be used to isolate and frame a chosen scene to help you decide how much landscape to include.

Alternatively you can make a viewfinder easily by cutting a hole in a small piece of card.

This rather more sophisticated frame, consisting of two right-angled pieces of card, enables you to vary the proportion of your aperture and allows greater scope for variation.

AERIAL PERSPECTIVE

Last week we looked at using one- and two-point perspective to construct scenes using straight lines. Another rule of perspective is that as an object recedes from the viewer, it becomes less defined and less intense, thus both softer outlines and lighter texture and tone are required when we draw an object that is a long way off.

Aerial perspective is particularly useful when it comes to drawing the large spaces of a landscape. Look at the drawing below and note how the use of aerial perspective gives the eye an impression of space moving out into the distance.

The tree in the middle ground has less texture and intensity than the bush.

The trees in the further distance are less well defined and more generalized in shape.

The hills in the background are softer and fainter in definition.

The nearest bush is still fairly strong in texture, in contrast to the tree.

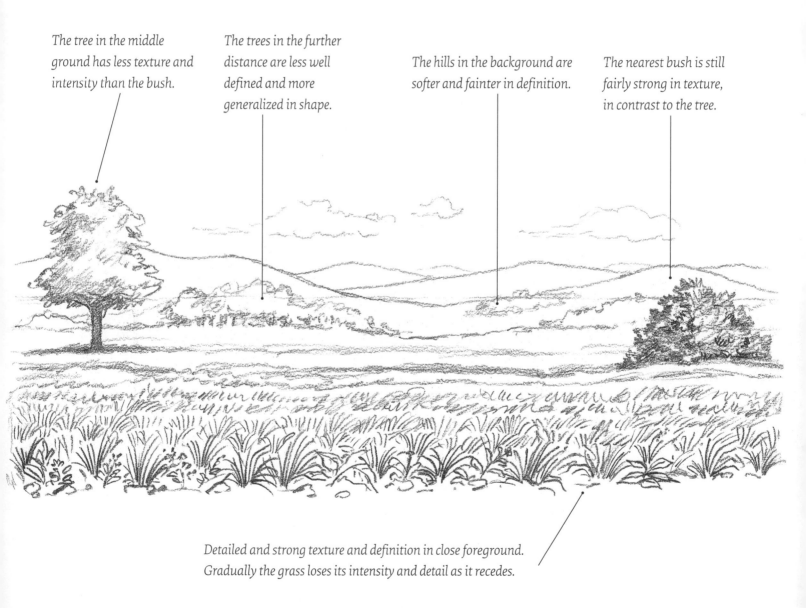

Detailed and strong texture and definition in close foreground. Gradually the grass loses its intensity and detail as it recedes.

THE TEXTURES OF LANDSCAPE

Before making a start on a larger scene, it is useful to familiarize yourself with some of the elements of landscape, including grass, plants, stones and water. Some of these are similar to the textures you practised in Week 2, but they incorporate the effects of aerial perspective you'll need for landscape drawing.

In this first exercise the method is to scribble lines outwards, without taking your pencil off the paper, until you have built up a mass of texture that rounds out into a bush shape. Then strengthen the marks significantly around one side to give a sense of depth.

The second practice produces the effect of an area of grass, again using simple scribbled marks. Working from the bottom upwards, gradually reduce the strength and the depth of your marks. This gives the impression of tufts of grass receding into the distance.

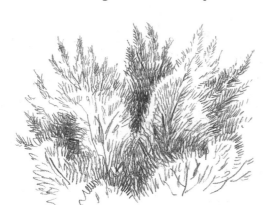

This drawing of a pine tree uses simple pencil strokes to represent the texture of the foliage. Note how I have put in some marks that resemble branches, to help show the structure of the tree. In some parts I have made the marks darker to denote deeper shadow.

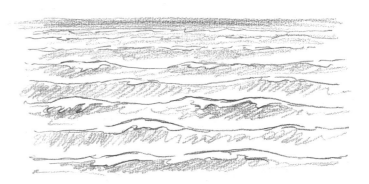

Moving on to the sea, this scene shows the ripples of waves as they recede to the horizon, where they become just a strip of tone. Draw the wave shapes in undulating horizontal lines.

Now we move on to a pebble or stony beach, where you have to be patient enough to draw lots of pebble shapes of varying sizes. The closest pebbles are drawn strongly and in some detail. On the far side of the ridge of stones, draw marks that look less definite and appear to be only the tops of pebbles, to give the impression of distance.

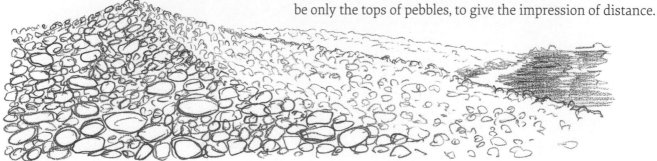

EXPLORING LANDSCAPE

This project is intended to get you thinking about how you might start a landscape proper away from home. I took a short trip to a wetlands nature reserve beside the River Thames in south-west London. The environment is especially dedicated to the flora and fauna of watery and marshy places, so although it isn't quite wilderness, it has a natural feel.

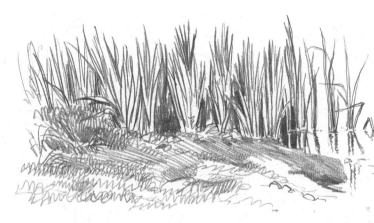

Initially I just wandered along and chose anything that seemed to be typical of the reserve. First I drew this clump of reeds beside the water, concentrating on the clusters of stalks as they rose out of the ground.

Next I came across an area where the terrain was mainly lumps of rock and stones, with a few boxes for nesting purposes and some reeds – quite a different feel to the previous scene.

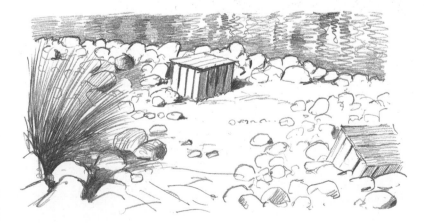

Then I concentrated on the bark of the trunk of a tree that was near the water. All these exercises got me into the experience of drawing in this type of place, with its varying forms and textures.

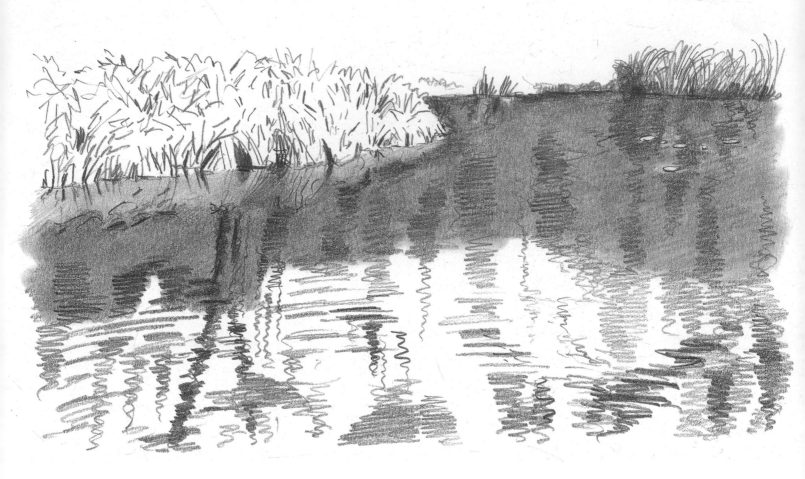

Then I decided to try out two examples of water, getting a feel for the texture of its surface and how the reflections appeared when seen in different lights. The first, which is a sheltered spot of water, has many reflections that are distorted just a little by the ripples.

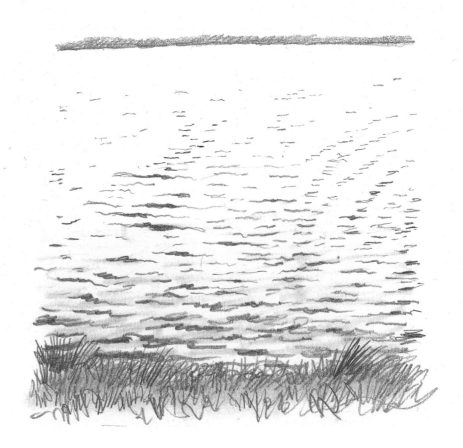

The other stretch of water was more open and had many ripples across the surface, but because of the angle at which I was viewing it there wasn't much in the way of reflection.

Next I began to consider the scene as a whole. Using my framing device to select a view, I drew this little wood cabin with trees around it and a path leading up to it from a bridge over the stream. There's a slightly more solid, hard-edged look to the scene.

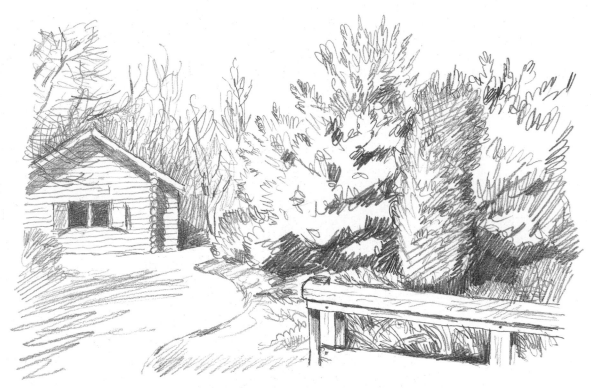

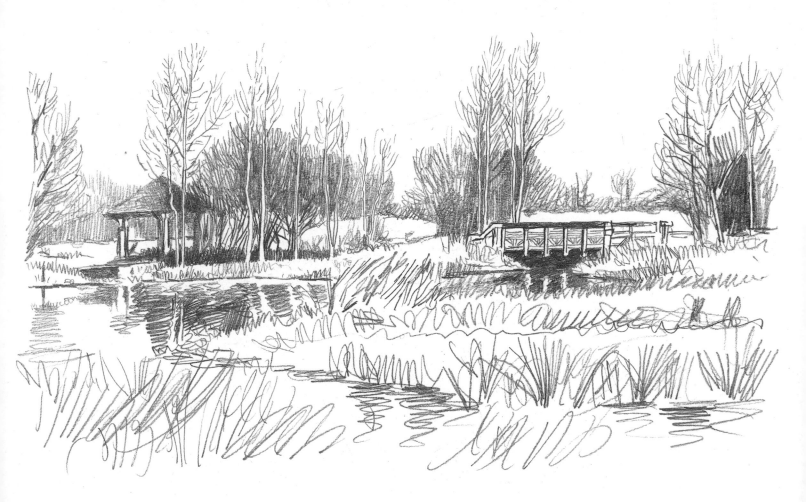

Then I looked at this rather more open expanse of stream and small trees, where there was another small shelter and a wooden bridge. The myriad streams threading through the landscape are more obvious here.

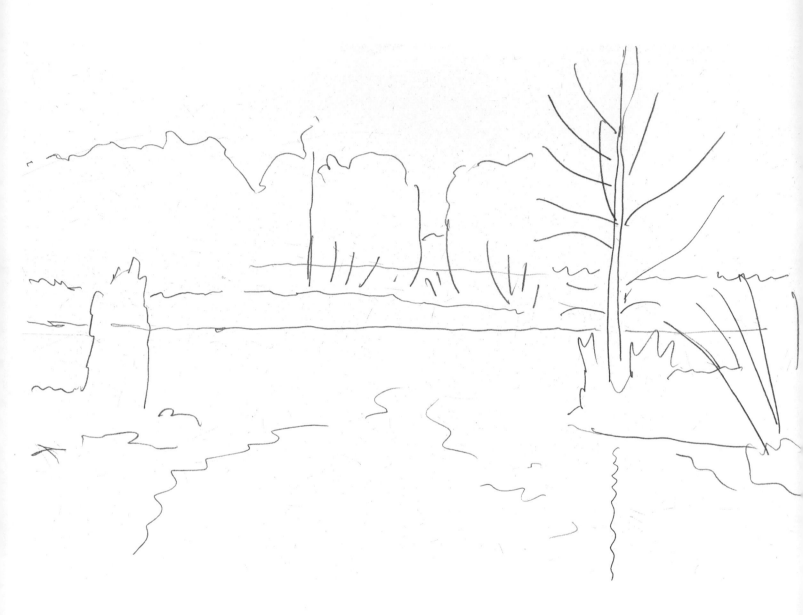

Step 1

Finally I decided to opt for this view across an expanse of stream with many silver birches and other marsh-loving trees scattered along the banks. At first I sketched in the main areas of the composition very simply so that I knew how much I was going to take on.

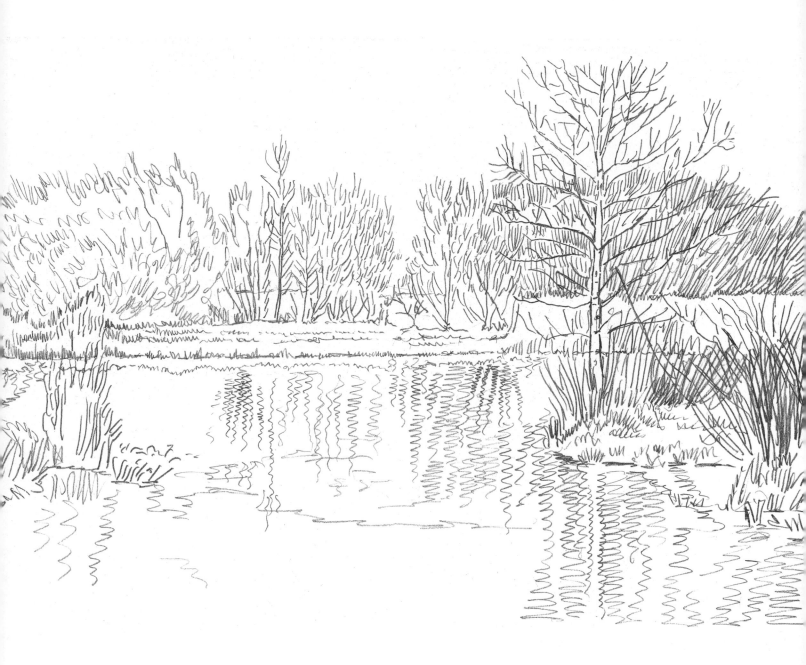

Step 2

Then I worked up the details of the trees and the water in a linear fashion so that I had the whole scene drawn up clearly and could make any alterations as I felt necessary. The water was marked with zig-zagging lines to indicate the location of the deeper reflections.

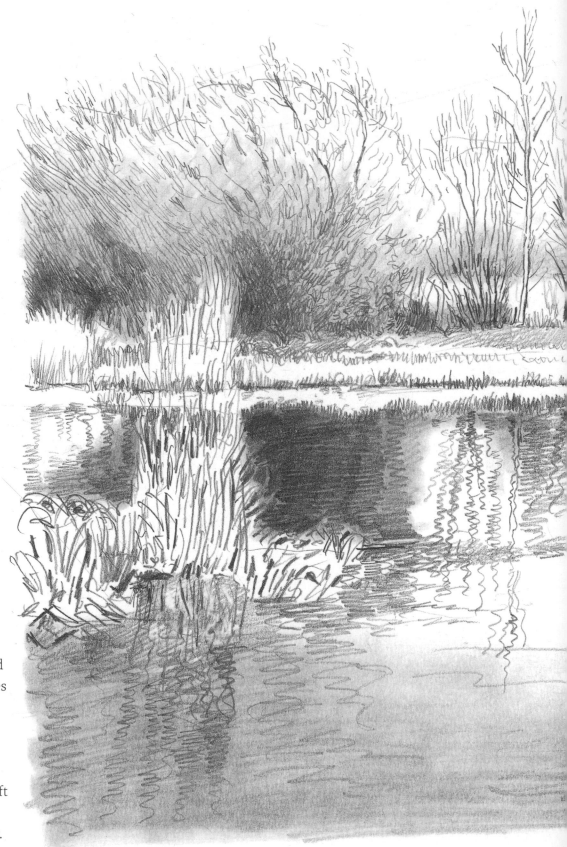

Step 3

To finish the drawing I carefully put in the tonal values so that the water and trees began to show more depth and spatial qualities. This is quite a simple scene in terms of composition, but the flimsy quality of the winter trees where I could see through their branches was quite a challenge – a very light touch was needed. To achieve the smooth tonal quality of the water I used a very soft pencil (7B) and smudged the marks with my finger.

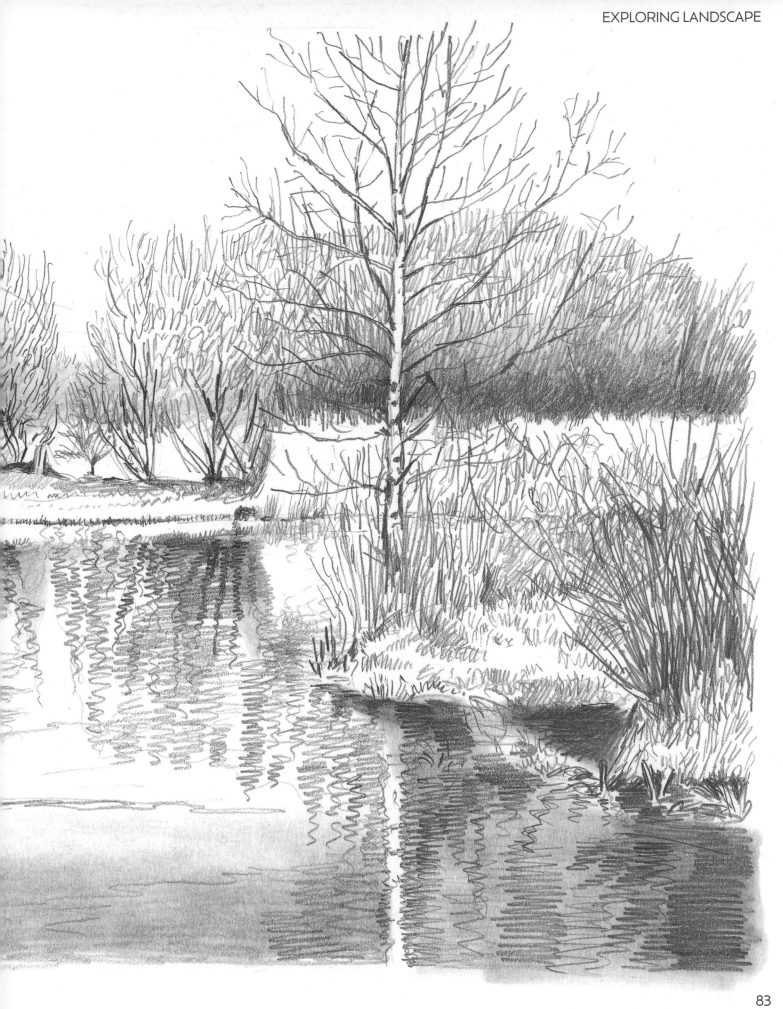

TYPES OF LANDSCAPE

Any natural landscape will be made up of one or more of the features shown on the following pages. These are sky, hills, mountains, water, rocks, vegetation, such as grass and trees, beach and sea. Obviously each of these elements offers enormous scope for variation. For the moment, look at each set of comparative examples and note how the features are used.

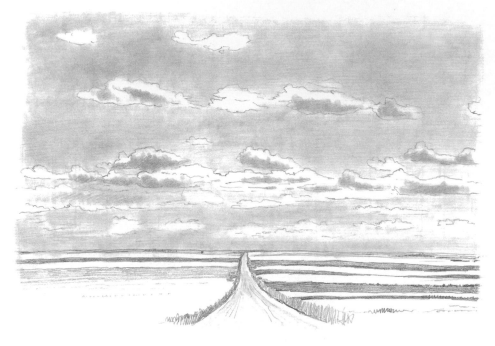

Skies and Hills

A halcyon sky takes up almost three-quarters of this scene and dominates the composition, from the small cumulus clouds with shadows on their bases to the sunlight flooding the flat, open landscape beneath.

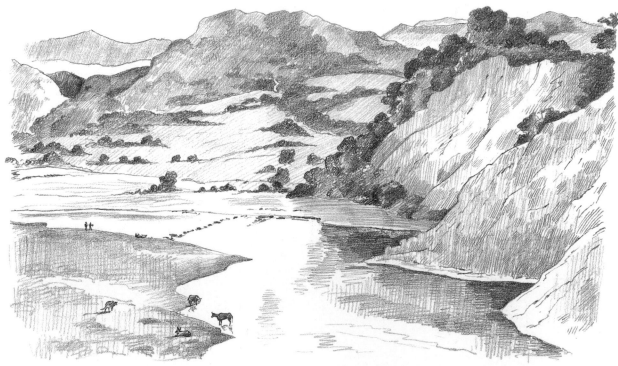

In this example the high viewpoint allows us to look across a wide river valley to rows of hills receding into the depth of the picture. The tiny figures of people and cattle standing along the banks of the river give scale to the wooded hills. Notice how the drawing of the closer hills is more detailed, more textured. Their treatment contrasts with that used for the hills further away, which seem to recede into the distance as a result.

Rocks and Water

The turbulence of the water and its interaction with the static rocks is the point of this small-scale study. Note how the contrast between the dark and light parts of the water intensifies nearer to the shore. As the water recedes towards the horizon the shapes of the waves are less obvious and the tonal contrast between the dark and light areas lessens.

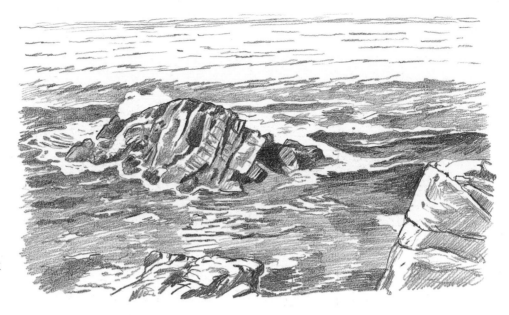

This close up of a rocky promontory shows starkly against a background of mountaintops drawn quite simply across the horizon. The rock wall effectively shadows the left-hand side of the hill, creating a strong definite shape. In the middleground large boulders appear embedded in the slope. Smaller rocks are strewn all around. Note how the shapes of the rocks and the outline of the hill are defined by intelligent use of tone.

The main feature in this landscape is the stretch of rocky shoreline, its contrasting shapes pounded smooth by heavy seas. Pools of water reflect the sky, giving lighter tonal areas to contrast with the darker shapes of the rock. This sort of view provides a good example of aerial perspective, with more detail close to the viewer, less detail further away.

Grass and Trees

Grass and trees are two of the most fundamental elements in landscape. As with the other subjects, there are many variations in type and in how they might be used as features.

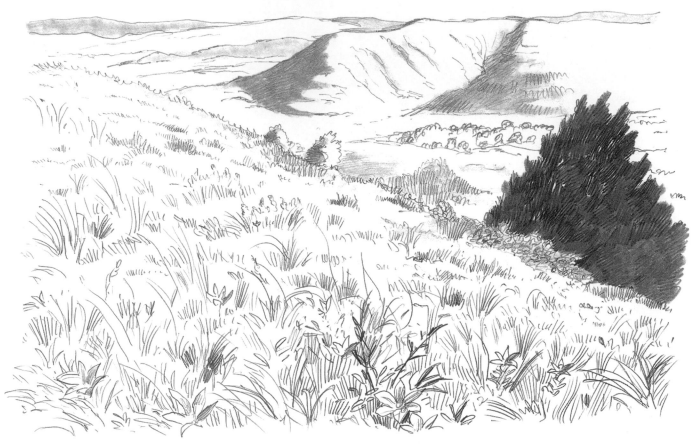

Tufts and hummocks of grass mingle with flowers in this close-up of a hillside. The foreground detail helps to add interest to the otherwise fairly uniform texture. The smoothness of the distant hills suggests that they too are grassy. The dark area of trees just beyond the edge of the nearest hill contrasts nicely with the fairly empty background.

As we saw on page 26, when you tackle trees, don't try to draw every leaf. Use broad pencil strokes to define areas of leaf rather than individual sprigs. Concentrate on getting the main shape of the tree correct and the way the leaves clump together in dark masses. In this copy of a Constable picture the trees are standing almost in silhouette against a bright sky with dark shadowy ground beneath them.

Beaches and Sea

Beaches and coastline are a rather specialized example of landscape because of the sense of space that you find when the sea takes up half of your picture.

Our first view is of Chesil Bank in Dorset, England, which is seen from a low cliff-top looking across the bay. Our second is of a beach seen from a higher viewpoint, from one end, and receding in perspective until a small headland of cliffs just across the background.

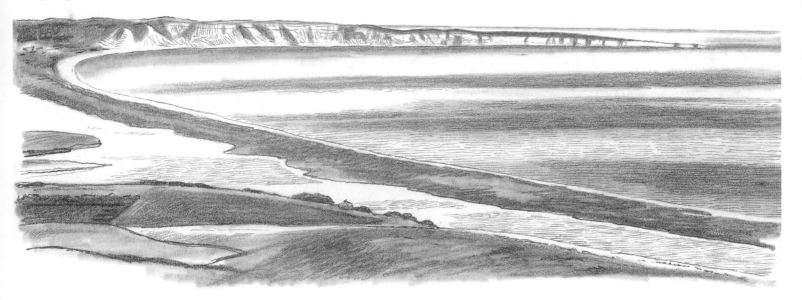

This view looks very simple. A great bank of sand and pebbles sweeping around and across the near foreground with a lagoon in front and right in the foreground, and hilly pastureland behind the beach at left. Across the horizon are the cliffs on the far side of the bay and beyond them the open sea. Notice the smooth tones sweeping horizontally across the picture to help show the calm sea and the worn-down headland, and the contrast of dark tones bordered with light areas where the edge of sand or shingle shows white.

In this view the dark, grassy tops of the cliffs contrast with the lighter rocky texture of the sides as they sweep down to the beach. The beach itself is a tone darker than the cliff but without the texture. The hardest part of this type of landscape is where the waves break on the shore. You must leave enough white space to indicate surf, but at the same time intersperse this with enough contrasting areas of dark tone to show the waves. The tone of the rocks in the surf can be drawn very dark to stand out and make the surf look whiter. The nearest cliff-face should have more texture and be more clearly drawn than the further cliff-face.

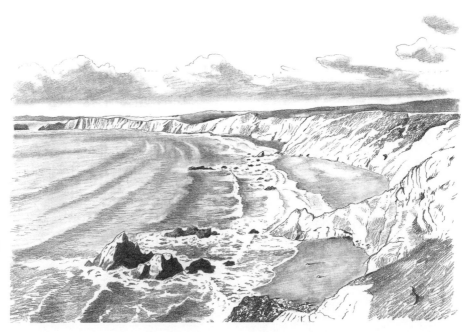

LANDSCAPES IN DIFFERENT MEDIA

The medium of tonal painting in brush and wash is time-honoured and beloved of many landscape artists, largely because it enables the right effect to be created quickly and easily. It also enables you to cover large areas quickly and brings a nice organic feel to the creative process. The variety of brushstrokes available enables the artist to suggest depth and all sorts of features in a scene. This imprecision is especially useful when the weather is a prominent part of the structure of your landscape and you want to show, for example, misty distance, rain-drenched trees or wind-swept vegetation.

As we saw on page 9, I recommend good-quality sable-hair brushes in two different sizes for this technique. The largest brush you will need for anything of sketch-book size is probably a No. 10. The No. 2 is small enough to paint most subjects finely.

You can use either water-soluble ink or just some black watercolour. To go out sketching with this medium, you will need a screw cap pot for water and some kind of palette to thin out your pigment. I use a small china palette that will go in my pocket or just a small box of watercolours with its own palette.

As a water pot I generally use a plastic film roll canister with an efficient clip-on lid, or a plastic pill-bottle with a screw cap. These are small enough to put in a pocket and easy to use in any situation. Laying on a wash of tone is not always easy, so you will need to practise. Try not to change your mind and disturb the wash as your picture will lose its freshness.

If you like this method of drawing, invest in a watercolour sketch book; its paper is stiff enough not to buckle under the effect of water, whereas regular heavy cartridge paper can buckle slightly.

The subject matter of this drawing (after Turner) is very appropriate for the medium, being rather soft in tone and contrast and simple in shape.

Chalk/Pastel

Chalk-based media, which include conté and hard pastel, are particularly appropriate for putting in lines quite strongly and smudging them to achieve larger tonal effects, as you can see in this example after Cézanne. The heavy lines try to accommodate the nature of the features and details they are describing.

The similarity of style over the whole rocky landscape in this drawing helps to harmonize the picture. Compare the crystalline rock structures and the trees. Both are done in the same way, combining short, chunky lines with areas of tone.

A TRIP TO THE CITY

So far this week we have explored largely natural landscapes, with few man-made features. This final project focuses on an urban landscape, combining street furniture, buildings in perspective and some human figures. I decided to go on a journey to get some examples of urban landscapes that had some direct significance for me, so I took the train to London's Trafalgar Square. This is one of the city's main focal points, and I thought that I would be able to find plenty of scenes that gave a good idea of the problems to be solved when drawing in a busy urban environment.

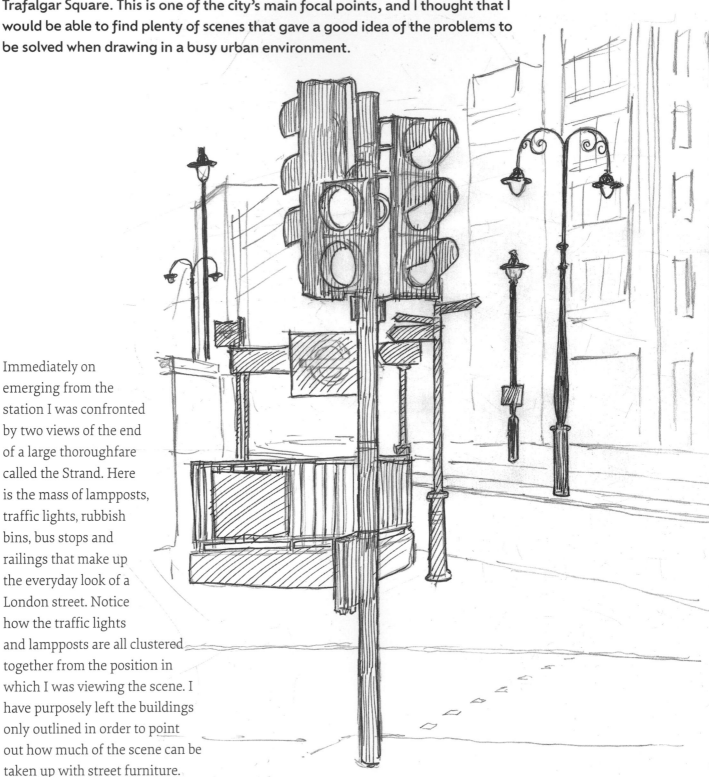

Immediately on emerging from the station I was confronted by two views of the end of a large thoroughfare called the Strand. Here is the mass of lampposts, traffic lights, rubbish bins, bus stops and railings that make up the everyday look of a London street. Notice how the traffic lights and lampposts are all clustered together from the position in which I was viewing the scene. I have purposely left the buildings only outlined in order to point out how much of the scene can be taken up with street furniture.

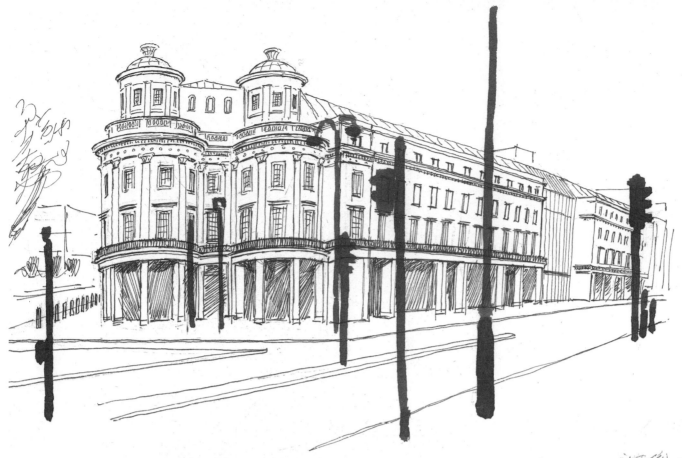

In the next drawing I've used a large watercolour brush to add the silhouettes of the lamps and traffic lights which actually punctuate the space along this street. They immediately break up the space in a rather interesting way that helps to give more of a sense of what it is like to stand in the position that I was drawing from. So don't ignore the street furniture, but if it tends to overpower your picture you can always leave some of it out. This is the selectivity that's expected of artists.

This view is from the top of the steps up to the National Gallery in Trafalgar Square. A large ornamental lamp stands in the centre of the picture, and around it can be seen a street of large classical buildings stretching off into the distance. The people dotted about help to define the space between the viewer and the buildings.

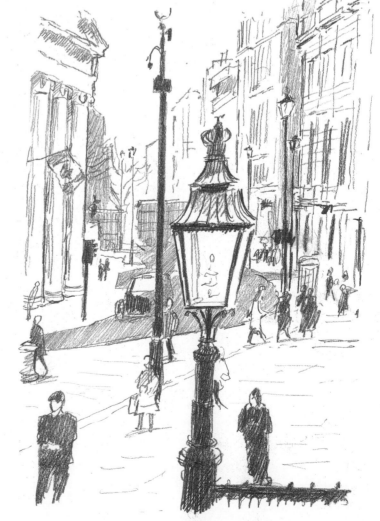

To make a sufficiently dramatic scene to show the most effective method of drawing in the city, I chose as large a panorama as I could of Trafalgar Square, without trying to get everything in. I placed myself in the middle of the steps of the National Gallery and looked straight across the square towards Whitehall with Nelson's Column right in the middle of the scene, but without being able to see the top, where Nelson's statue stands. This gave me a focal point for the scene without including a large expanse of sky. After all, I wanted to portray the city buildings rather than just the central column.

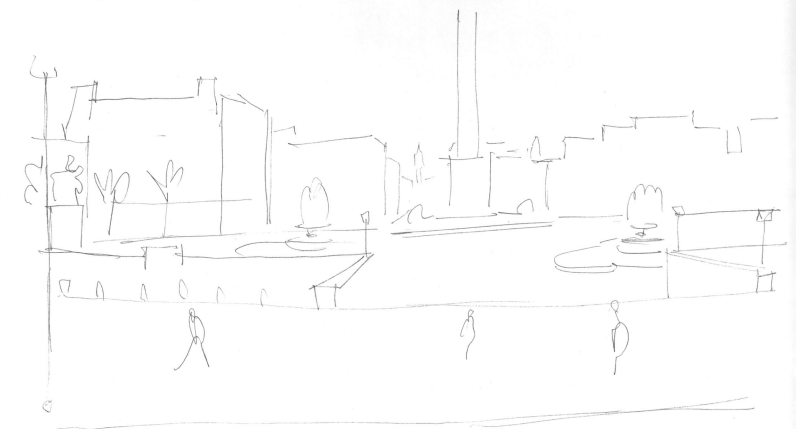

Step 1 (above)

To start with I sketched in the main areas of the blocks of architecture, indicating the open space of the square where people were wandering about. I did this in pencil so that if any of the spaces were wrong I could erase them.

Step 2 (opposite top)

Next, still using pencil, I drew up the whole square in some detail, although the large numbers of windows visible were put in as simply as possible. At this stage I could still alter anything that didn't work, and if I decided I didn't like the position of a tree or lamppost, or even a rooftop, I could get rid of them. My aim was to maintain the overall spacious quality of the scene rather than worry about every detail.

Step 3 (opposite bottom)

Having got the whole scene drawn in I could now put in more people, and add some tone as well. I decided to mainly use ink and so the first thing was to draw the whole picture all over again with a pen. This may seem a bit tiresome, but it can often lead to a better picture. I also started to mark in the tones of the main buildings with a very soft all-over tone, which helped to show up the white splash of the fountains in the square. I did this with pencil to keep it soft at first, then I went over all the areas that I wanted to be more definite with inked-in areas of tone, which looks a lot darker than the pencil. At this stage I put in a lot of people crossing the square and looking at the fountains.

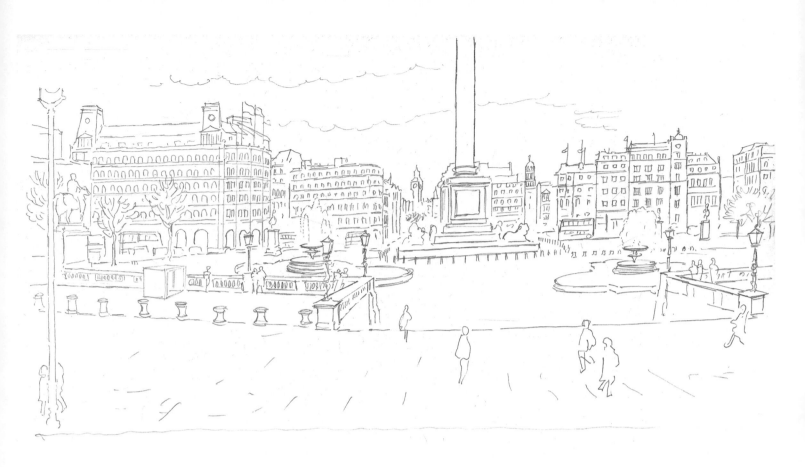

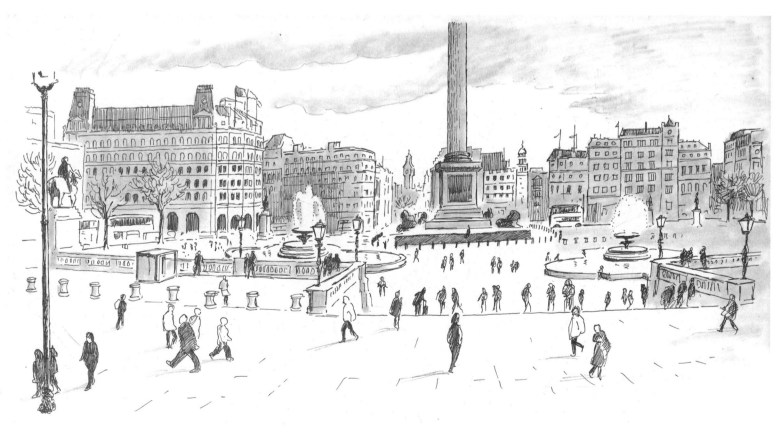

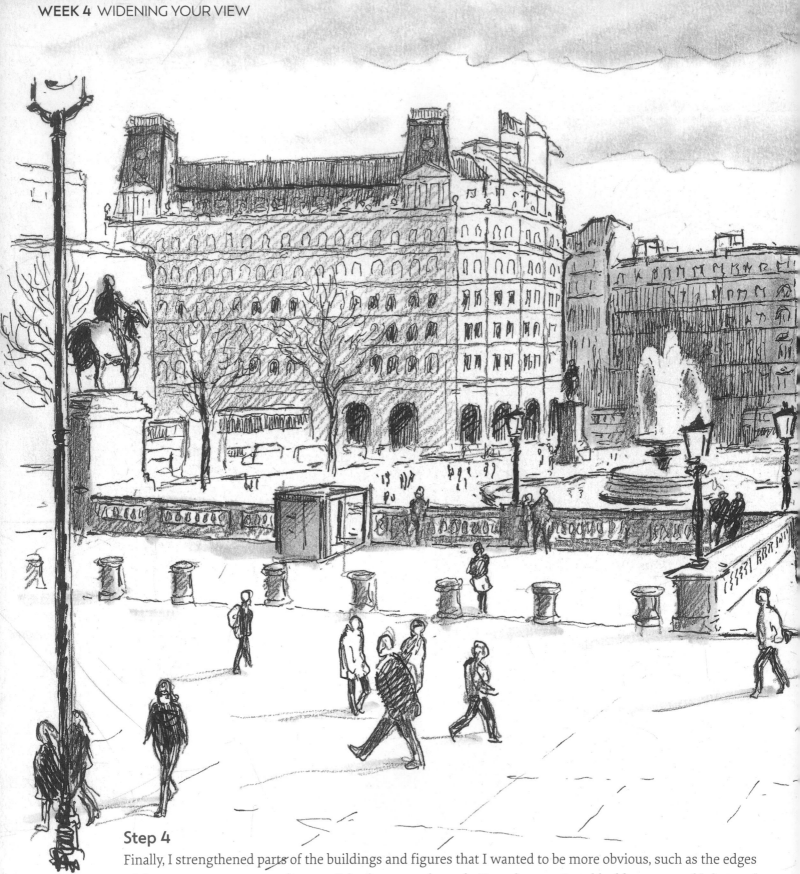

Step 4

Finally, I strengthened parts of the buildings and figures that I wanted to be more obvious, such as the edges of the nearest structures and some of the foreground people. From here on I could add more tone bit by bit with either pencil or ink until I was quite sure that I had given the tonal values their due and made the buildings look as solid as they should. I particularly made sure that the white water of the fountains stood out against darker backgrounds. As in any landscape, the elements further away – in this case the buildings – are less defined than those closer to the foreground.

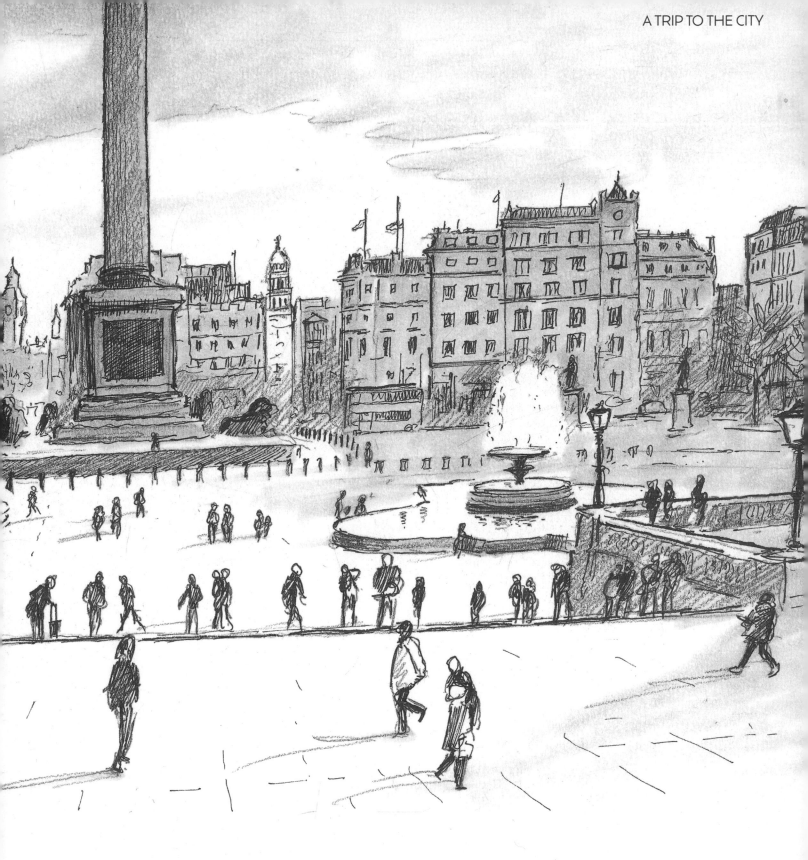

When you come to draw your own urban landscape, you can follow the steps shown here or take a trip to your own local town or city centre. This is a large-scale, ambitious picture to finish your four-week introduction to drawing; make plenty of sketches and be prepared to dedicate some time to the project. Consider the skills you have learned during the course and congratulate yourself on coming this far!

INDEX